Drawing and Painting
HANDS & FEET

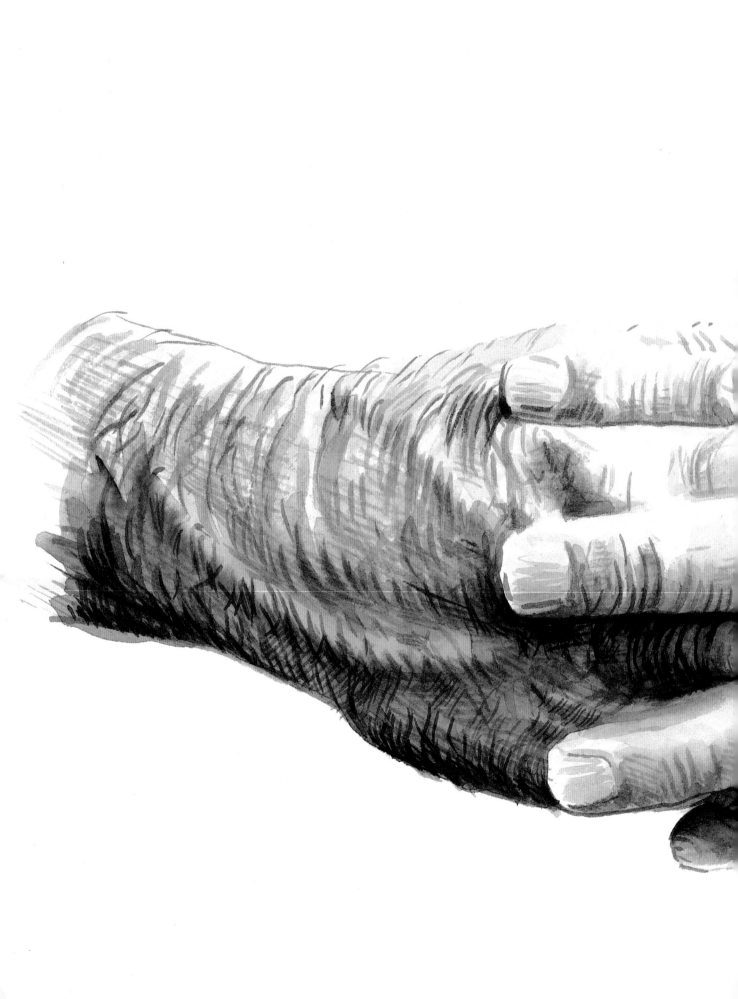

Drawing and Painting
HANDS & FEET

Robert E. Fairley

WATSON-GUPTILL PUBLICATIONS/NEW YORK

First published in the United States of America in 2000
by Watson-Guptill Publications, a division of BPI
Communications, 770 Broadway, New York, NY 10003

First published in the UK in 2000 by David & Charles

Library of Congress Catalog Card Number: 00-109497
ISBN 0 8230-1466-5

Printed in China by Leefung-Asco
for David & Charles
Brunel House Newton Abbot Devon

Publishing Director Pippa Rubinstein
Commissioning Editor Anna Watson
Art Editor Diana Dummett
Desk Editor Freya Dangerfield

Contents

Drawing Exercises 40–75

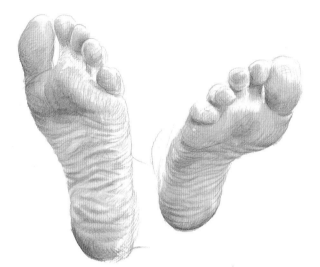

Progressing to Painting 76–125

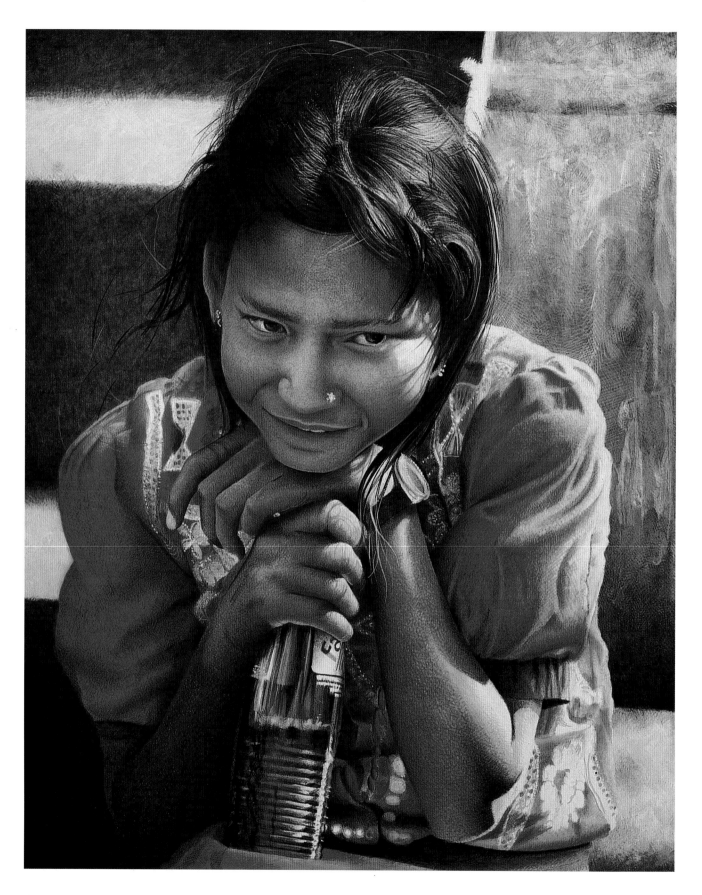

Introduction

Painting is an expressive medium and, unless you have plans to become a medical illustrator, it is important to remember that the ability to portray hands and feet is not an end in itself but only a further addition to your basic skills, to which observation is the key. As Sherlock Holmes points out to Dr. Watson in *A Scandal in Bohemia*: 'You have not observed, and yet, you have seen – that is my point.' That indeed is the whole point: you must teach yourself to see, but, more importantly, to thoroughly observe and to understand what you see.

As I write this, I am sitting on a train climbing steeply past the dark windswept and ice-fringed waters of Loch Treig and up onto the Moor of Rannoch in Scotland, one of the last true wilderness regions left in northern Europe. High above the loch, the gray and turquoise mountaintops are just beginning to be separated from the receding night sky by a slow-spreading, sea-trout-pink glow, which as we travel, intensifies to deep salmon in a dawn of violent beauty. I sit and watch and scribble this while my mind constantly strays to memories of the companion with whom I last walked across this bit of country. But what has this got to do with drawing hands and feet?

The answer is the ability to observe a subject, be it a broad landscape or the closer view of a figure. In the train carriage sitting opposite me is a woman who got on at a remote stop some minutes ago. She is in her mid-thirties and is wearing a small, smart, black, expensive party dress, dark tights, thick red woollen socks and heavy working boots. Her hair is black, glossy and beautifully styled and she has spent considerable time putting on discreet makeup. On the table between us she has laid a heavy waxed jacket that has seen better days and is searching through its pockets for something. She has found her ticket and is now gently nibbling a corner of it. Her hands have rarely seen hard work, but an angry scar curves across her left wrist tapering up into the base of her thumb; her nails are almost perfect, though she has not yet replaced yesterday's polish, which is heavily chipped. The nail of her little finger on her left hand has been

bitten to the quick. Her wedding ring is on the second finger of her right hand; she wears no other jewellery. She is not happy, she has not noticed the sunrise. She smells strongly of stale beer and chips.

If I were to paint her portrait, (and I may well do so), all the details mentioned above would become important, as would questions such as, where does she come from and where is she going? Why is she dressed in such a strange combination of clothes? Why has she chosen to sit opposite me when there is nobody else in the carriage? As the train swings across the moor the light on her hands changes. When the rising sun catches them, they glow an expressionistic red and orange, her ring turns to white flame and the scar on the wrist turns a dramatic purple. Then as we change direction, the pale, reflected pinks from the mountain opposite become the dominant light, the scar disappears into the shadows and her ring echoes the cold yellow of the train's fluorescent lighting.

Next time you are on a train or bus, look closely at the person opposite you. Watch how his or her hands hold a newspaper, notice how the muscles in the wrist move when they turn a page, and if they have their sleeves rolled up, watch how the muscles high up the arm move to activate the fingers. Teach yourself to take every opportunity to observe and understand how the muscles work. By this I mean, for instance, working out what your arm feels like when you move your wrist. We take the sensation for granted, and it will take some concentration to realize that you can feel your muscles expanding and contracting. Watch your leg closely when you wiggle your toes, watch your arm while you wiggle your fingers, look for the dramatic movement right up the arm when you clench and unclench your fist. Consider the enormous activity starting from the buttocks all the way down your leg when you bend your knee and point your toes.

Observation and experiment

Parbati, Swayanbonath, April 1997

When drawing or painting the human figure, the structure

7

and mechanics of all the parts must be understood, but I am not going to burden you with a complex anatomical treatise. It is not necessary to know all the names of the bones, tendons and muscles in the hand or foot to draw them successfully. You will improve by drawing as often as possible. The only advantage the 'trained' artist has over the 'untrained' is the hours of practice he or she has put in, but this can often be diluted by an increasing belief in a formulaic approach. Much of the work involved in the artist's study of anatomy involves simply looking closely at how the body works.

The nineteenth-century anatomist, Charles Bell (related to Joseph Bell, the inspiration for Sir Arthur Conan Doyle's Sherlock Holmes) wrote in his important treatise on the hand: 'Painters proceed by experiment.' And indeed they do, but by experiment born from observation. If painting (or any other art form for that matter) ceases to be experimental then its very purpose is lost. Too many artists set out thinking that they know how the final product will look, or how they wish it to look. Nearly all art teachers, at every level, teach that this is the way to proceed; they set a goal and then show how a number of rules are employed in order to attain it. This is in line with nearly every other subject in the academic curriculum, giving students the illusion that rightness depends on fealty to rule. Spelling and arithmetic may be rule-following subjects, but the arts are not.

The arts, and painting in particular, require an ability to surrender to the unanticipated possibilities of the work as it unfolds. The artist should seek the surprises that redefine goals. Thus your work should be, rather than a monologue, a conversation that is punctuated with all the surprises, arguments and uncertainty that make dialogue so interesting and stimulating. Your aim should not be to impress what you already know into a material, but rather to discover what you don't know. You will not, therefore, discover in this book a magic formula or set of rules that will enable you to draw hands and feet. They do not exist. You will, however, learn a lot about how hands and feet work and how, by close observation, you can make your drawings and paintings have greater veracity.

It is also worth remembering that it is not necessary to have a bit of paper from a college or university 'proving' you can draw. Art schools are a comparatively recent invention, and the majority of artists in the past did not have such proof. The importance of such certificates is often exaggerated. Our local college runs a course in 'life skills' (do they mean breathing?), so, logically, if you believe you can only learn to draw at an art college, then can you also only have a life with a 'life skills' certificate? Instead of developing a complex about having a lack of training (as so many do), I suggest you follow Rembrandt's advice: 'Take a brush in hand and begin… the work is complete when you have no more to say.'

Learning by touch and sound

A large majority of the exercises in this book can be undertaken using yourself as the model, and I suggest that you start by conducting an exploration of your own body with your hands, beginning with your head.

The head

Start by gently tapping around your eye socket; you will be able to hear rather than feel when you are tapping against bone and when you are not. You may be surprised to discover how large the eye socket is. Continue by tapping down the nose; you will find that the 'sound' alters dramatically as you move from the nasal bone to the cartilage that makes up the lower nose. Now place an index finger at the base of each ear and tap down the line of the jaw; again the sound will change if you go off route. Replace your index fingers on the inside base of each ear and your thumbs at the point where the jawbone curves in to meet at your chin. Your middle fingers will now be resting just to the side of the opening in the ear. Open and close your mouth. Move your jaw from side to side as if you were a cow chewing its cud. Were you aware of the fact that every time you speak, the bone you feel under your middle finger moves so dramatically? Obviously this is important to the portrait painter but he does not need to know its name, only how it works. The mandible (lower jaw) is the only movable bone of the skull, so the portrait painter has it easy.

Portrait of a girl on a swing

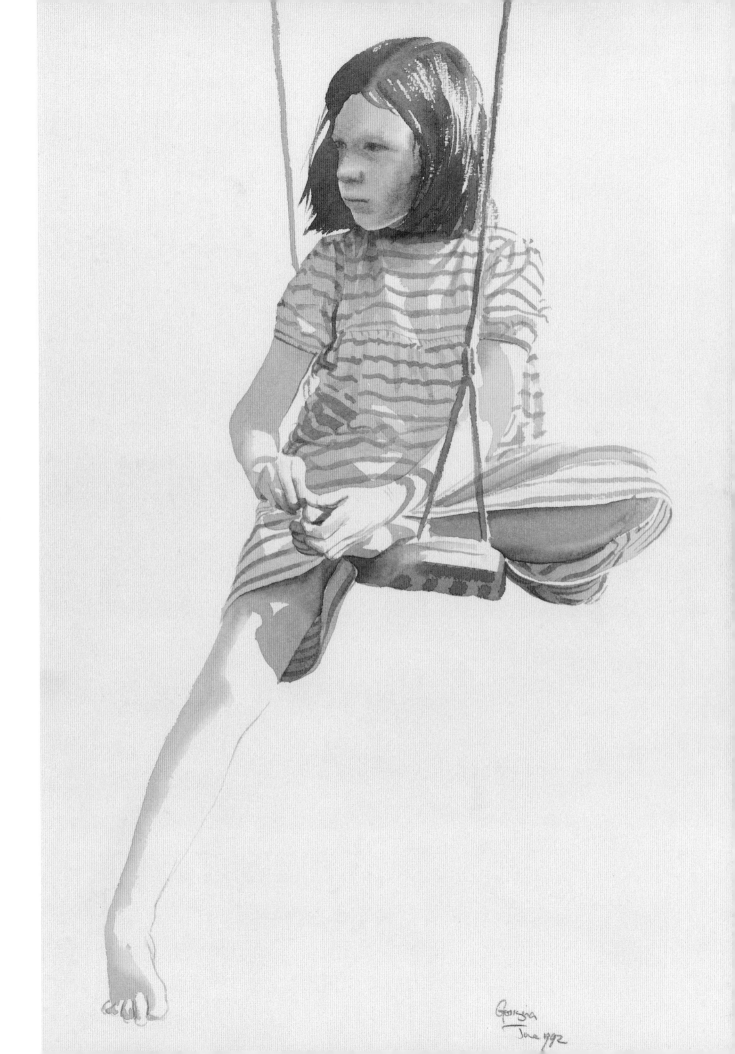

Georgia
June 1992

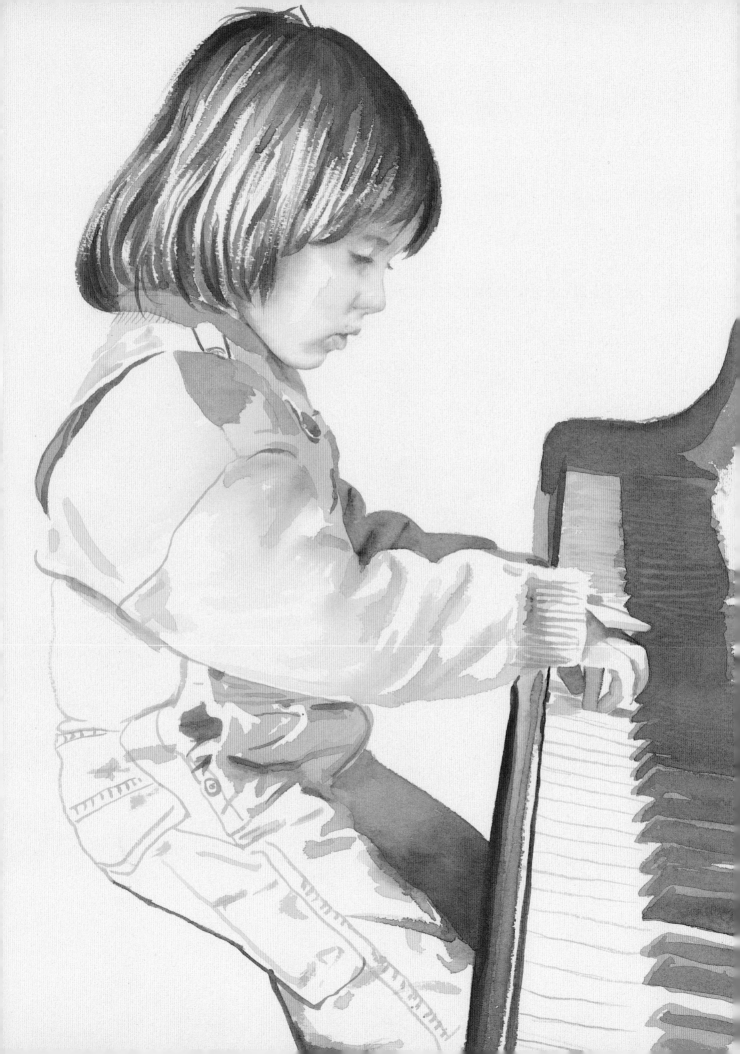

Legs and feet

Using a similar technique, let's try a speedy exploration that is more closely directed to our area of study. Sit comfortably on a chair with both feet on the ground about 20cm (8in) apart. Place both hands around the top of one of your knees so the fingers meet on the underside and with your thumbs pointing forwards. Now wiggle your big toe up and down. You should feel very noticeable movement on the inside of your leg. Move your hands so they cradle the front of your knee and again wiggle your big toe – you will feel pronounced movement, and if you slowly move your hands down your leg you will find this movement becomes more pronounced, and then halfway down almost disappears. However, if you keep moving your hand down, and keep wiggling your toe, you will rediscover the movement in the ankle.

Stand up and place a hand on the back of your thigh just below the buttock, and again wiggle your big toe up and down. You should be able to feel movement with your hand, and you will also be able to see and feel that your knee moves backwards slightly. Trace the movement down your leg exploring back, front and sides. This will give you a very clear idea of where the muscles that move the big toe lie. You will also notice that even the slightest movement affects the way the whole leg looks.

Repeat the previous exercises, but this time take particular note of where you can feel bone. In most cases you will not be able to feel much movement in the bones, and from this you will realize that the muscles work the bones and not the other way around. You will also see that some of the bones come very close to the surface, most obviously the knee joints and those down the front of the leg.

Arms and hands

The hands are more flexible than the feet, so the amount of movement detected in the arm is even greater and more obvious. Place one wrist with the palm of your hand facing down in the palm of the other hand, and grip firmly but not too tightly. Flex your fingers up and down and you will feel considerable expansion and contraction. Roll up your sleeve and, with your palm still facing down, place your elbow in the palm of the other hand and again flex your fingers; then

Girl playing the piano

move your hand so it is resting on the top of the elbow joint and repeat the flexing of the fingers. Obviously, the majority of the muscles required to waggle your fingers up and down lie on the underside of the arm. Repeat this exercise but open and close your fingers like scissors. Can you feel any difference? Once again explore the full range of movement in your own arm and hand, and again take note of where the bones are close to the surface.

Experiment with media and approach

Since observation is the key, it might be reasonable to finish the book at this point as you now have all the essential information literally at your fingertips. Close observation of other people coupled with intelligent study of your own body should answer all the questions you are likely to come across, and I presume that you would not be reading this if you did not already draw and weren't interested in the practicalities of drawing and painting.

One problem, however (apart from the obvious objection by the publishers), is the ease with which many artists fall into the trap of only working in a particular medium or material at the expense of all others. While this will build up a high degree of skill, it will be in a very narrow range and this in turn leads to laziness and sloppiness of thinking. If you work all the time in pencil (or watercolor, or pastel or whatever) you will rapidly develop a vocabulary of marks which you know can describe particular things and you will then use these marks at the cost of developing others which may (or may not) be more precise. What is worse, you will look at an object and immediately conjure up a series of marks which you know from experience will work in explaining it. You will cease to think about what you are doing and will end up with a piece of work which does not differ at all from anything you have produced before. In other words, the experimenting will disappear from your work.

If you look at the great draftsmen of the last hundred years, such as Picasso, Hockney or Manjit Bawa for example, you will find that they constantly change media in an attempt to avoid falling into the trap of making clichéd marks and producing meaningless work. I encourage you, therefore,

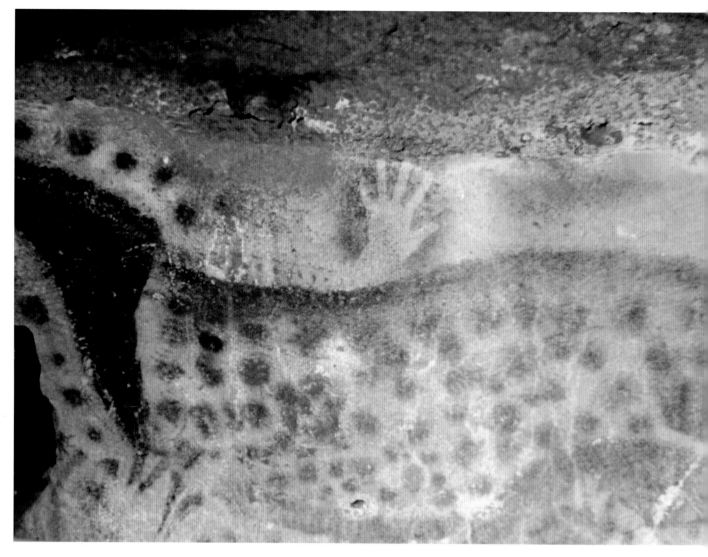

The depiction of human form is very rare in Palaeolithic art. These powerfully moving signatures are from a cave in southern France and date from 27,000–30,000BC. This was a time when, perhaps, artist, magician and priest were one.

while working through this book to constantly change the media you use and to experiment, experiment, experiment. Do not copy my illustrations. There is nothing to be learned from doing so other than developing the ability to reproduce 'Fairleys', and nobody in their right mind would want to do that! You always have a model available (you), so use it!

Materials

Many artists have a firm idea of which materials they will use for drawing and which for painting, but the distinction between drawing and painting is in fact quite blurred and probably unimportant. In the introduction to a catalogue of the drawings of Joseph Beuys (1921–1986), Anne Seymour gives a formidable list of materials used by the artist: 'Oil paint, gold paint, watercolors, plant juices, chemicals, blood, chocolate…collage of virtually anything flat, from pressed flowers to felt and toenails.' She then proceeds to the surfaces he used: '… cardboard, notebook and diary pages, sketchbooks, kitchen paper, newspaper' – and then points out that he used 'whatever is to hand'. You can use anything you like to make an image. There are no rules, other than those you choose to impose upon yourself. I have but one rule: I will not sell anything that is not as permanent as I can make it.

Charcoal and graphite

The earliest, most profoundly moving examples of hands in

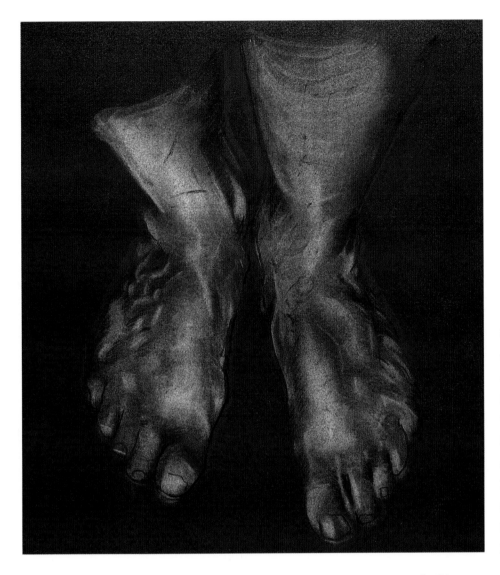

Working from dark to light with charcoal
Cover a piece of paper with an even layer of charcoal and then use an eraser (trimmed to a point) to draw with. Pick out the areas on which the light falls and then use your stick of charcoal (or try used matchsticks) to draw further into the shadows.

Western art are in a cave in the Ardeche region of southeastern France. These date to an astonishing 30,000BC and were made using earth and charcoal. Charcoal, carbon, chalk and graphite are among the most basic of all materials, and while it is possible to use found or homemade versions, you will probably find them easier to buy. All are available either in their natural state or in compressed sticks, and you will find they work well on almost any surface although papers with a rough finish will allow a greater depth to be achieved. Up until about 50 years ago, an art student newly enrolled into an art college could expect to spend a considerable period of time copying a whitewashed plaster cast of some Greek or Roman antiquity using nothing more than a stick of charcoal and a piece of paper tightly rolled into a point (called a stump) and a piece of bread as an eraser. He or she would be expected to produce a drawing of considerable accuracy before eventually being allowed to

progress to the life room, only then to discover, of course, that living models resemble neither Greek gods nor plaster casts! The drawing technique itself, however, can be adapted, as I have done for the drawings on pages 62–63.

Instead of fixing your work with a proprietary fixative, try using hairspray, which is considerably cheaper and does an equally good job, if not a better one! The best hairspray is the cheapest you can find, ideally made for greasy hair; it is available both non-perfumed or perfumed (if you fancy sweet-smelling drawings, then by all means indulge yourself).

Graphite is most easily managed in the form of pencils and, as I am sure you are aware, they come in a wide range, from 6H (possibly even 8H) which is hard enough to cut your paper, through to 8B, which will provide soft, deep darks. If you work on a reasonably large scale you will get through them quite quickly, so be prepared to replenish your supplies

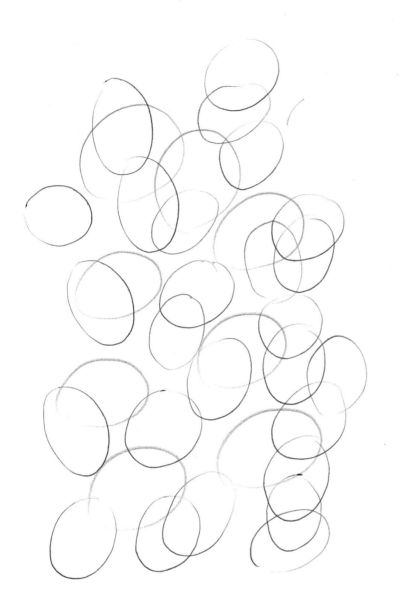

The 'egg-drawing' exercise

Try to draw an egg in one line and without the pencil leaving the paper so that it looks three-dimensional. Draw quickly and fluidly. Start by pressing hard and as you progress, release the pressure so that the line steadily becomes lighter and at its lightest opposite the point where you started. Slowly increase the pressure until you arrive back at the starting point, when you should be using exactly the same pressure as when you started. Then try the exercise the other way around by starting with a light line, and progressively adding weight before completing the egg as you started.

frequently. Experiment with the whole range before you make up your mind which you prefer – and remember that they are tools, and that one will be more suitable than another for a particular job, just as you would choose a wrench depending on the size of nut you wish to loosen. Try combining grades of pencil, particularly the very hard (4H, 5H, 6H) with the very soft (4B, 5B, 6B).

There is an exercise, reputed to be an apprentice test used in the Florentine Renaissance workshops, which can be attempted with any drawing implement, but which is ideally suited to the pencil. It is excellent preparation for the drawing

exercises that follow, and I urge you to do it. Imagine an egg shape illuminated from one side, and with a single continuous line, attempt to draw it with a pencil, as shown on this page. Producing an even egg shape is not as easy as it sounds! Practice. Doodle nothing but eggs; the pad by the telephone and indeed the telephone directory itself should soon be covered with them.

The egg-drawing exercise develops all the skills needed to make a line dance across the page: light to dark, thick to thin. It also builds up a wonderful control over your medium. In the days when handwriting was taught in schools it was not

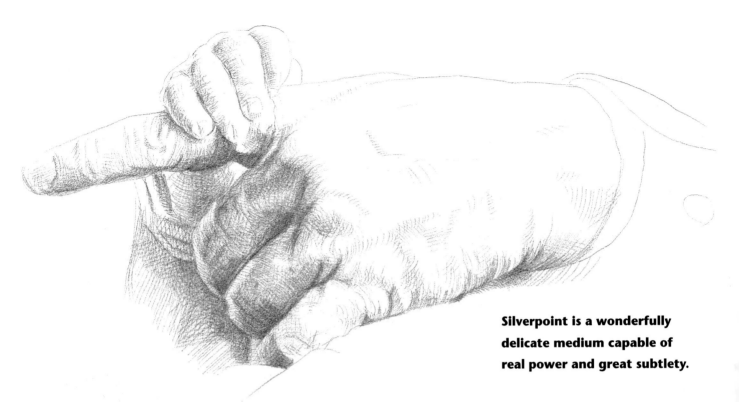

Silverpoint is a wonderfully delicate medium capable of real power and great subtlety.

necessary to point out that lines could be thick or thin, but now it is a skill that needs practice. When you get tired of eggs, try a series of flicked lines. These are easy going from dark to light, but it is important to try the other way around as well. Draw straight flicked lines and curved flicked lines. Finally attempt to write your name pressing lightly on the up strokes and firmly on the downstrokes. Try the other way around as well. Slowly build up speed. All these exercises should be attempted with all the media you use, and they provide a basic vocabulary for all the drawings that you see in this book.

Ink and ink substitutes

Ink seems to have been invented in China and Egypt, around 2,500BC, and was basically a mixture of carbon and binders. This description is simplistic in the extreme, particularly when it comes to describing traditional Chinese and Indian inks, which are most complex mixtures. Chinese inks are sold in little sticks, which are rubbed with water on small shallow dishes. Even the way the rubbing is carried out is said to alter the delicate nature of the color.

An enormous number of inks are available and once again

I would suggest you shop around before settling on any one make, brand or color. My favorite (at the moment) comes in the form of a powder, which, when mixed with water, gives a beautiful range of purple blues, and after a while takes on a subtle coppery sheen. I think it was originally school ink because I obtained it when a local village school closed down. Remember that ink or ink substitutes are sold in all sorts of shops, not just art shops. Take a walk around your local supermarket; food coloring is much cheaper than ink and you will find an almost complete range of colors available (I have used it for the drawings on pages 48–49). Blackcurrant juice, tomato juice, coffee (used on page 58), tea and hair coloring also make reasonable drawing media.

Pens and other tools

If the variety of ink-like substances is only limited by your imagination, then the implements with which you apply them can be equally varied. Sticks, reeds, grasses and, of course, feathers all make good tools, and every artist should at some point in her career make her own quill. By coincidence, as I began to write this section I received a letter from a colleague asking whether I thought a dip pen with a

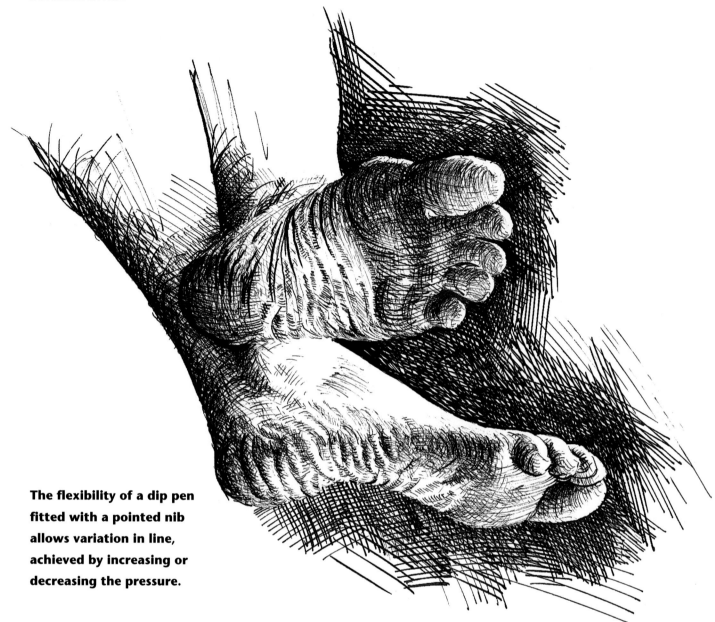

**The flexibility of a dip pen
fitted with a pointed nib
allows variation in line,
achieved by increasing or
decreasing the pressure.**

flexible pointed steel nib was a valid drawing tool at the start
of the twenty-first century. I think it is. No, I know it is. None
of the differences and changes in society has altered the
relevance or importance that dance has for mankind;
drawing, particularly with pen and ink, is a form of dance. In
the East, the hands are more important than the feet in
dance, and being able to dance a nib across paper will always
be a profound way for one person to speak to another, and to
speak across the centuries. Dip pens and nibs are not so easy
to find these days (except in specialist art stores), however, if
you look, you will turn some up, often in unlikely places: try
thrift shops and garage sales. Having found or made your
drawing implement, try the egg-drawing exercise again. It

will be even more difficult now, because you must not only
vary the weight with which you apply your tool, but also
control the flow of ink by turning the nib.

Fountain pens work well, but beware of using them with
'drawing' inks as many contain shellac, which will soon
render your pen useless. I find the ball-point pen a poor tool
because of its steady unvarying flow of ink, but there is
nothing to stop you using one if you like them; they are
certainly better than nothing. The various fiber-tipped pens
suffer from the same condition until you have used them for
a while; they are not among my favorite implements either.
Children's felt pens are fun, but be aware of the fact that few
of the colors are lightfast. This is good news if your kids have

A monochrome watercolor study. Notice that it is possible to indicate the correct shape of a foot even when shoes are being worn. Look closely at the angle of laces, patterns and markings.

just attempted to emulate Michelangelo on the bedroom wallpaper, but bad news if you have just spent several hundred dollars on a felt-pen drawing.

Silverpoint

One other drawing implement worth mentioning, if for no other reason than that the majority of manuals leave it out, is the silverpoint. This is quite simply a piece of sharpened silver wire (obtainable from a silversmith) held or bound to some form of holder. The most ingenious holder I have encountered is a pin vice obtainable from any jewellery supplier; however, attaching the wire to a stick with a strip of adhesive tape works just as well. You will have to treat the paper before use: a thin wash of gouache will do the trick, although you could try the traditional method, which involved grinding burnt chicken bones to a very fine powder and mixing them with gelatin. The silverpoint line is beautiful and delicate (see pages 50–51) but unless it is protected by a thin varnish (hairspray again) it will tarnish. I find the tarnished line even more attractive. Gold and platinum wire can be used instead of silver; they will produce different colored lines and do not tarnish.

Pastels and colored pencils

Pastels and colored pencils sit in the hinterland between drawing and painting, the best being made with colored dye or mineral that is identical to that of paint. Pastel is a remarkable medium capable of both great delicacy and strength. I find colored pencils and water-soluble colored pencils to be very useful drawing tools. When working on a study I like to have several pencils of the same color at hand, ready sharpened, so that I do not need to break my concentration to sharpen one.

Watercolor, acrylic and oil paint

As well as using watercolor as a painting medium in its own right, I like to use it as a drawing medium with graphite and colored pencil.

Acrylic paints enjoy tremendous popularity, but I rarely use them as I think that the jury is still out on the question of their permanence. I find it disturbing that many of the world's great art collections spend more on conserving works made in the last 50 years than they do on works that were created 500 years ago.

Oil paintings usually take me many months to complete, but oils can be used as a sketching medium, and two of the demonstrations were made in this way, and were completed in one sitting. I do not use the recently introduced water-based oil paints, for the same reason that I tend to avoid acrylics.

Surfaces for drawing and painting

The first author of an instructional book on painting was an artist called Cennino Cennini; he wrote *The Craftsman's Handbook* in Florence during the fifteenth century. He gives very precise details of how to prepare a 'little boxwood panel…so as to be able to start drawing.' This process took several hours; indeed he recommends that you spend at least two hours grinding 'very fine' bones from a fowl 'just as you find them under the dining table' to form the white surface of your panel! Fortunately you do not have to go to such lengths to find something to draw on.

Many people buy a small sketchbook and work quite happily in that. The only thing wrong with this is the fact that you are restricted to one paper size and one paper surface. Instead, I suggest that you invest in a drawing board (a piece of marine plywood is ideal), and that you choose a size somewhat larger than you think you will need. My boards are 60cm x 1m (2 x 3ft) and they easily take a full sheet of paper – although you may find half this size ample. Onto this, stretch the paper you intend to use for each exercise. I believe that it is good practice to stretch paper, whether you will be using it for dry or wet media, though of course you will have your own preference.

Stretching paper seems to have assumed an aura of black magic and causes many people much distress; however, it is quite easy. Soak your sheet of paper in the bath or in the sink, or with a large sponge or decorator's brush, making sure both sides of the paper are wet. Place the wet paper on your drawing board and fix it around the edges of the paper with 5cm (2in) gummed brown paper tape (the sort you have to dampen, not self-adhesive tape). Then gently remove any surplus water and leave it to dry.

Choice of paper is a personal matter. All my drawings in my degree show at college were done on bank statements, advertising fliers and junk mail, indeed anything that was free. These were then stretched and the surface altered by

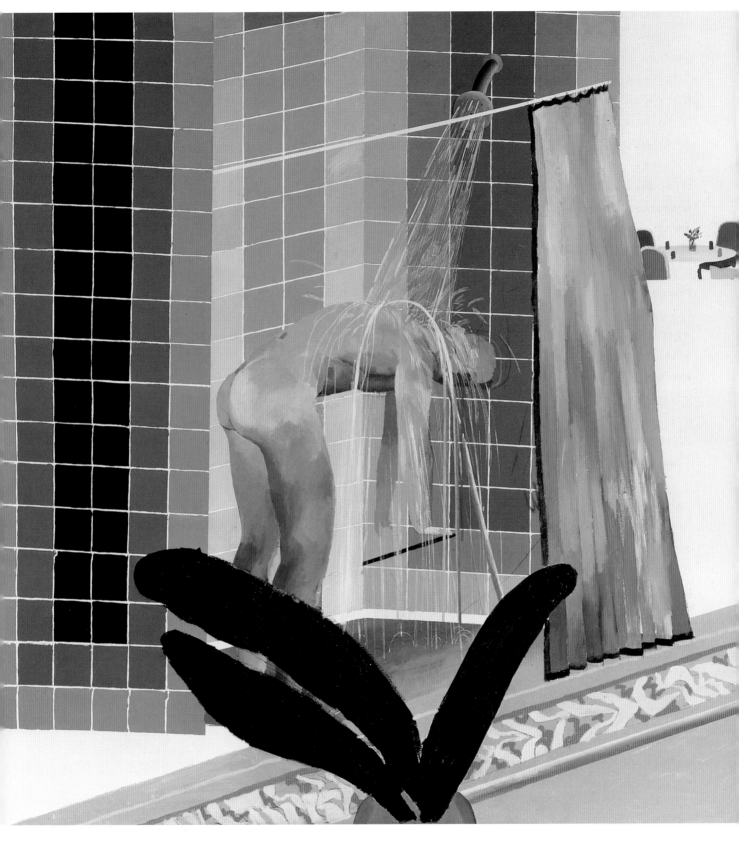

**Man in Shower in Beverley Hills,
David Hockney (1964)**

paint and sandpaper to suit the medium I was using. The drawings for the first two sections of this book were done on a cheap cartridge paper, a parchment-colored Hannemuhle watercolor paper and a 150gsm Saunders watercolor paper, the two watercolor papers having a NOT surface. The watercolor, acrylic and pastel paintings in the third section were also made on watercolor paper.

Pastels need to be worked on a surface with a degree of texture to hold the pigment particles. The artist Joan Eardley (1921–1963) used to rub two sheets of fine-grade sandpaper together until they appeared almost smooth; she then used these as a surface for her extraordinarily tender portraits of children, and for the wild, exciting sea- and landscapes she produced towards the end of her life.

The oil sketches in the third section were made on board. I use seasoned wooden boards, prepared in the traditional way with rabbit-skin size and a gesso, or egg and oil emulsion ground, sometimes with an oil primer. You could experiment with paper, card, canvas, slate, stone or even metal.

Drawing and painting the figure

Painting is the only art form that does not require the element of time for its magic to work. Music, dance, theater, film, poetry, literature all require time for the full impact and meaning of the work to be revealed; even sculpture requires the fourth dimension to appreciate the other three. Painting, however, can speak across the centuries in a flash. This is not to say, of course, that spending time with a great work will not cause your appreciation to deepen and your

understanding to grow. Of course it will. However, the initial reading, the initial shock of seeing, exists immediately, without the intervention of time.

If you look through the history of painting (Western painting in particular), you will find that a surprising number of great painters have managed to achieve this magic in their drawings and paintings of figures by leaving out hands and feet. Some artists are wonderfully honest about doing so. David Hockney, a supreme draftsman who usually has no problems with hands or feet, said of his painting *Man in Shower in Beverley Hills*: 'I had great difficulty in painting the figure's feet and, although the plant in the foreground was a definite early part of the composition, I did take a rather easy way out by bending the leaves to cover his feet.' Many others are less forthright, however.

Hands and feet are not difficult, but they do require acute observation and thinking. If you follow the exercises and studies in this book your skills will improve, and you will start to think about your work in a fresh way. The painting demonstrations in the final chapter of the book put hands and feet into context, and will give you an insight into the way I approach my work, showing how a painting can change direction as it progresses. Your job is to be honest to yourself and with yourself, remembering Rembrandt's words: 'The work is complete when you have no more to say.'

Girl on Swayambunath Steps

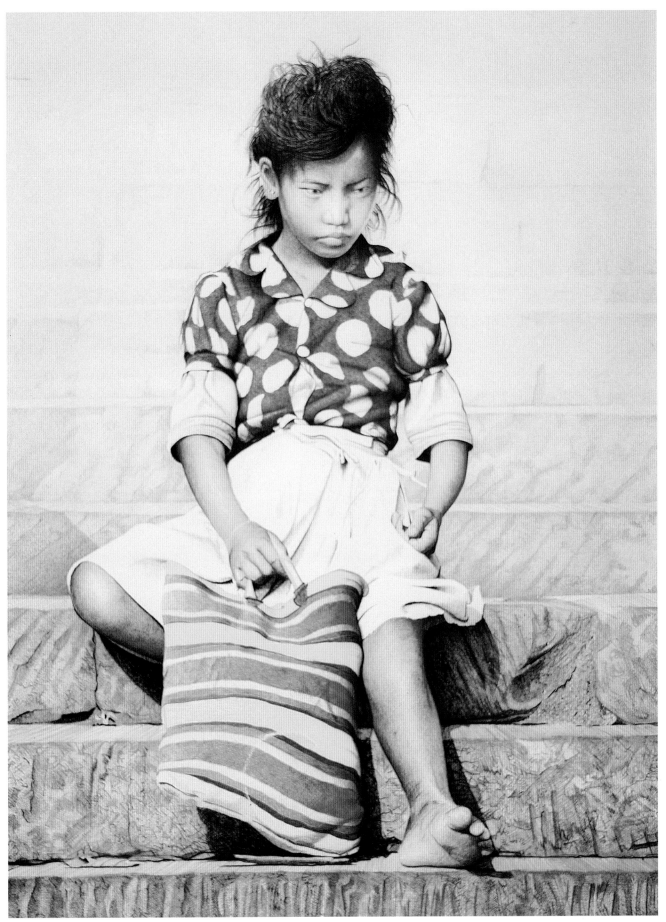

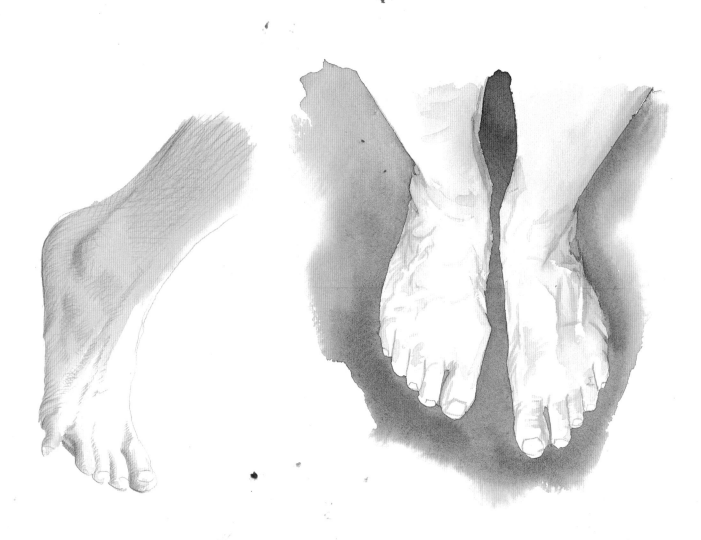

Structure and Anatomy

The study of anatomy will undoubtedly help your understanding of the movements of the figure, but it is not a prerequisite and indeed can lead you to drawing what you think should exist, even though your eyes are telling you that it patently does not. After all, you don't need to make a study of geology to draw a landscape.

Many teachers advise that the fledgling artist draw cylinders, circles, rectangles and all manner of geometrical shapes as a skeleton structure over which to draw the figure. This has always seemed to me to be at best ill-advised, and at worst a way of working that could well lead to bad drawing and an inability to understand what drawing is really about. Nature is not made up of geometrical forms, and by starting with such a premise one is forced into a tight formula that bears little relation to the way we see or think. The

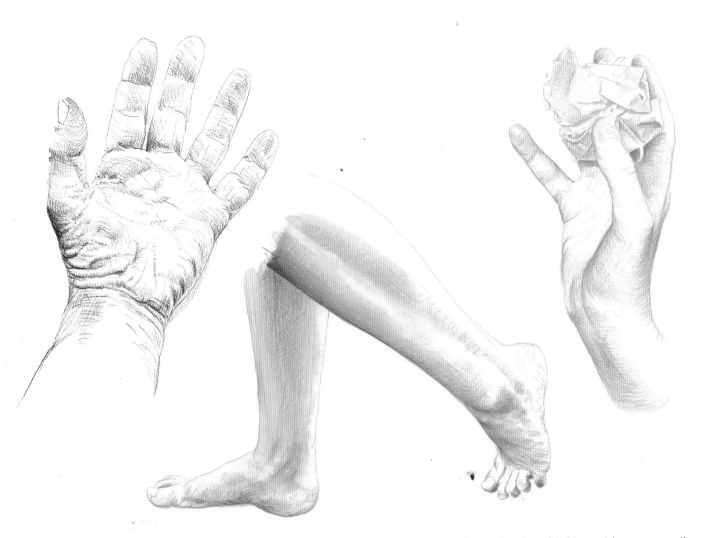

following pages will, I hope, introduce you to a new way of looking at the figure, and just as importantly, a new way of thinking about its form and structure.

When reading through this chapter for the first time I suggest that you use the time to learn about your body and observe how it works and why, and then, after working through the drawing exercises in the next chapter, return to this one and use these poses for further drawing study. When looking at the illustrations ask yourself why I chose the media I used, and ask yourself if you would have made the same choices. If you wouldn't have, do you know why?

You may find, as I do, that thinking without a pencil in your hand is virtually impossible. If this is the case, most certainly feel free to scribble some sketch notes. The writer Bruce Chatwin once said, 'If I can't walk, I can't write.' I find that if I can't draw, I can't think. Teach yourself to think about what you are seeing, and try to regain the young child's ability to constantly question 'why?'

Skeleton of the arm and hand

I have already introduced you to the idea of discovering for yourself what is actually there by touching, squeezing and tapping, and by moving your own hands and feet and feeling what is happening (see pages 8–11). Some bones will be easy to locate, others will be under too much muscle (and perhaps fat) and you may have to refer to the X-rays on these pages for verification, or if you want a name for the parts. This will be much more useful in the long run than providing you with annotated diagrams, which might give you the illusion of being able to identify bones that you have not truly observed.

It goes without saying that the hand is connected to the body by means of the wrist and arm. The bone in the upper arm is the humerus, a long bone with a rounded head, which fits into a socket in the shoulder. At its lower end it curves slightly forwards, becomes flattened, and terminates on each side in subcutaneous prominences called condyles.

The lower arm has two bones: one is the ulna, a long bone situated on the inner side of the forearm. The back of the top of this bone is the elbow, and from here to the wrist is a thin line of the bone that lies just under the skin. The other bone in the lower arm is the radius, which is nearly as long as the ulna and lies beside it. It is shaped so that while (obviously) it must follow the extension of the arm, it can rotate at the point where it meets the humerus and crosses over the ulna. The radius is thicker towards its head at the wrist, where it is attached by ligaments to the ulna. The bones of the wrist are attached to the radius by further ligaments so that when the forearm turns, the hand follows.

The structure of the hand is made of three parts: the wrist (carpus), the palm (metacarpus) and the fingers (phalanges). The wrist is curved and made up of eight bones called carpal bones. They rotate on the head of the radius and can be moved easily up and down and from side to side. The head of the ulna is an obvious, prominent bump on the back of the wrist on the little finger side.

There are five metacarpal bones that articulate with the bones of the wrist; each ends in a small ball-and-socket joint at the knuckle. The fifth, which forms the thumb, is capable of a wide range of movement.

Each finger consists of three phalanges, while the thumb is made up of only two. The fingernails overlie the last of these.

It takes about 20 years for the bones to develop (or ossify) fully. The X-rays of a child's arm and hands show how unconnected the bones are at this stage.

Child's arm, front view

The lower arm has two bones: the ulna and the radius. The back of the top of the ulna forms the elbow. The radius thickens towards the wrist, where it is strapped to both the wrist and ulna by ligaments.

humerus radius ulna

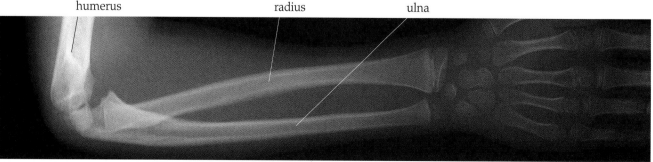

Child's arm, side view

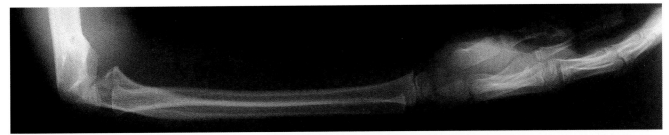

Adult hand, front view

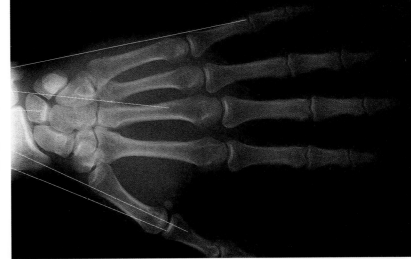

fingers (phalanges)
palm (metacarpus)
wrist (carpus)

thumb
ball-and-socket joint

Adult's left hand, front view

The eight carpal bones of the wrist articulate on the head of the radius and with each other. The nearest ends of the metacarpal bones of the palm articulate with the carpal bones, and also with the bones of the fingers by means of small ball-and-socket joints at their furthest ends.

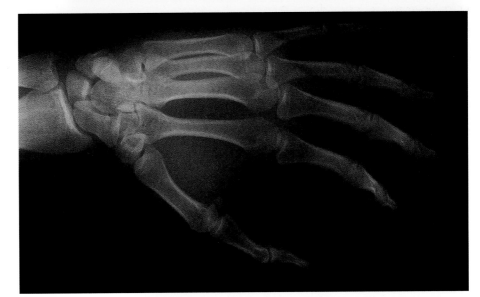

Child's left hand, front view

The undeveloped bones of a child's hand can be seen clearly in this X-ray. Notice in particular how the ball-and-socket joints have not yet been formed.

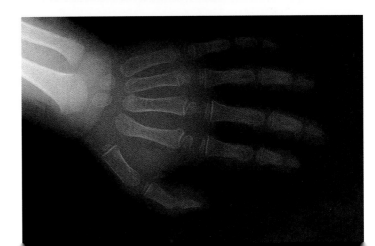

Skeleton of the leg and foot

The bones of the lower body are obviously heavier than those of the upper body. There is much less movement in the structure of the foot than in the hand, but because many of the bones are close to the surface, it is important to have some understanding of them.

The upper leg consists of one bone called the femur. This is the longest bone in the body, and its lower end forms a hinge-like joint with the tibia, the larger of the bones in the lower leg. The kneecap, or patella, is a small, triangular-shaped bone that sits on the front surface of the lower end of the femur. The tibia is a three-sided bone and lies on the inside of the leg with the whole of one of its sides (facing forwards and inwards) lying just under the skin. The other bone in the lower leg is called the fibula. It is very thin and is normally almost entirely hidden by muscle. The only place you can feel it is as the outer anklebone, which, it

should be noted, is lower than the inner one. The tibia and fibula are rigidly attached to each other at their extremities by ligaments, allowing little movement.

The foot consists of three parts: the tarsus, the metatarsus and the toes. The tarsal bones are bigger than the carpal bones of the wrist because they have to bear the weight of the whole body, but are similar in that they are irregular in size; they extend about half way along the foot. The largest of the tarsal bones, the calcaneum, which is square in shape, extends back beyond the bones of the leg to form the heel. The metatarsals are five curved bones, similar to the metacarpals in the hand, the thickest belonging to the big toe. Its neighbor is the longest of the five. The big toe has two bones and the others three, and, like the hand, the toenail overlies the last of these.

Ankle of right foot, front view

The lower end of the tibia creates the inner anklebone, or malleolus, which is slightly higher than the outer malleolus made from the lower end of the fibula.

fibula
tibia

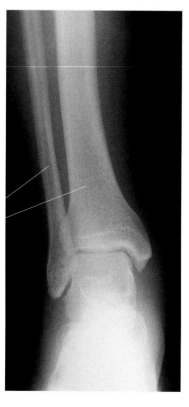

Ankle and heel of right foot, side view

The largest of the tarsal bones, the calcaneum, forms the heel. The tarsus bears the weight of the whole body.

ankle and heel (tarsus)

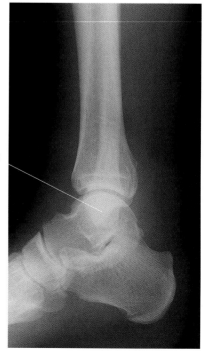

Right foot, front view

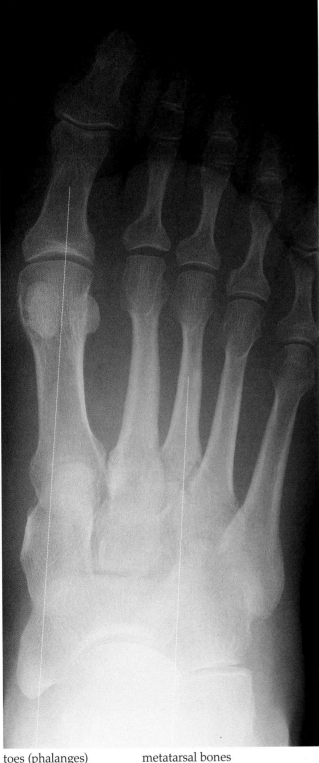

toes (phalanges) metatarsal bones

The metatarsals connect with the ankle and heel (tarsus), and by ball-and-socket joints with the toes (phalanges). The metatarsal of the big toe is the thickest, and that of the second toe is the longest.

Right foot, three-quarter view

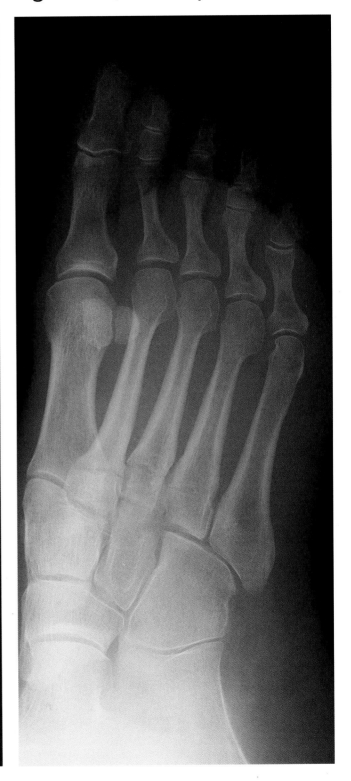

The metatarsal bones can be seen more clearly here. Viewed from this angle, the curve of the instep is also visible.

Muscles of the forearm

Having located the bones, you can now learn how they change position, moved by the muscles which are attached to them. Also notice that the hand you use the most will be stronger and that this will result in all the muscles in that arm being more developed. For the purpose of the following exercises, if you are right-handed look at your right hand, and if left-handed, your left. At first, just look, do not attempt to draw, but notice how I have dealt with conveying the forms (you will see that 'outlines' are an ever-changing phenomenon).

The drawings are done on cartridge paper with a pencil that is a souvenir from the Great Wall of China, and which appears to be the Chinese equivalent of HB. The model for the majority of the drawings on this page was left-handed and female.

Study 1 Stand in front of a mirror dressed in a loose-fitting, short-sleeved top with your arms hanging loosely at your sides. The first thing that should be obvious is that the forearm tapers towards the wrist, and if you conduct the tapping exercise that I described on page 8, you will find that the bones project increasingly as you approach the wrist between muscles and tendons. Slowly close your hand and open it again. You will see that there is movement on the outside of the arm about a palm's width up from the base of the thumb. This movement will have a slight curve to it and is controlled by the extensor muscles, which originate at the elbow and whose purpose is to straighten the wrist, fingers and thumb.

Study 2 Now hold your arm away from your body with your palm facing the mirror. The forearm still tapers, but not as much as when it is seen side-on, as in the previous study. Tap the soft 'underbelly' of the arm; this is where the majority of the veins carrying blood to the hand run, where, of course, they are better protected from damage. Clench your fist, however, and this soft underbelly changes dramatically. Try tapping down this part of the arm, first with the hand open and then with the fist clenched. With the fist clenched you will be able to see and feel quite clearly three of the stretched tendons in the flexor group. The flexor carpi radialis is the prominent tendon nearest the thumb. The middle one, which you may be able to feel extending down to the palm, is called the palmaris longus. The lower one is the flexor carpi ulnaris.

Study 3 The carpi radialis is quite pronounced in this drawing of my hand, seen as a light triangle in the wrist, but is well disguised by wrinkles in the skin caused by the hand muscles. These we will explore on page 30.

Study 4 Stand side-on to your mirror and once again let your arms drop to your side. Gently bend your fingers and then, without moving your hand or arm, turn your body 180 degrees, watching closely how, as the light changes, the muscles are delineated. Return to a side-on position and look very closely at the arm. You will see that the muscle mass noticeably curves in from the outside to the inside. It is important, therefore, when drawing the arm not to concentrate on the outline because almost any line you see beginning on the edge of the arm is going to end within the outline. It is often said that in nature nothing has an outline, and this holds true for drawing an arm. (Look again at the drawings on the opposite page; they were intentionally drawn by concentrating on the outline. Notice how an attempt has been made to show light and shade by the strength of the line – remember the egg-drawing exercise on page 14 – and how, even here, many of the 'outlines' become 'inlines'.)

Muscles of the hand

Having identified how the arm controls the hand, now look more closely at the hand itself, again using your own to observe form. The hand is a complex structure, and you will soon notice that the subtlest of movements brings a number of muscles into play.

When drawing the hand, it is also important to ask yourself why a particular hand looks the way it does. The model used for the first four studies has spent a lifetime driving heavy-goods vehicles, so his arm, wrist and hand muscles are all strongly developed. Compare these hands to those shown opposite of a woman of the same age and a child. All the lines in these drawings follow and describe the shapes of the hand. Those of the man's hand were drawn with colored pencil; the drawings of the woman's and the girl's with water-soluble colored pencil with touches of water.

Study 1 Roll up your sleeves and arrange a light so that it casts strong shadows across your arm, then place your hand palm down on a flat surface. Hold your elbow with the other hand and slowly turn your hand to a palm-up position (as in Study 2). As you turn the hand you will feel the turning motion at the elbow. The large muscle along the top of the forearm that you can see flexing and changing shape is called the supinator radii longus, and closer to the surface is the extensor carpi longus. It is the supinator that is turning the wrist.

Study 2 With your hand in the position shown at right, try to touch your little finger with your thumb. You will notice a flickering muscle movement at the wrist and possibly along the inside of the forearm. If you turn the whole arm over and repeat this action, you will see movement in a series of muscles which cross diagonally from the outside of the forearm, near the elbow, to the inside of the wrist. This set of muscles can be highly developed in squash players and other athletes, and you need to include the curve of its line to portray the forearm realistically.

Study 3 Although the hand in this picture on the left is in the same position as in Study 2, looking at it from this angle (closer to eye level) clearly reveals the two muscles at either side of the base of the palm. Stretch your hand as wide as it will go and gently stroke the base of the thumb. You will find, probably to your surprise, that there are two muscles: flexor pollicis brevis and abductor pollicis brevis. If you mark the line between the two you will find that your drawing has more veracity.

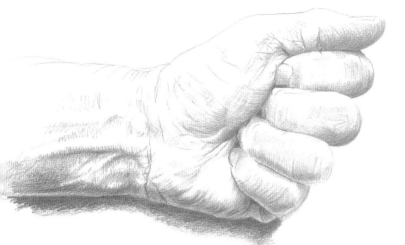

Study 4 Clench your fist, first with your fingers on top of your palm and then, as in this drawing, with the fingertips tucked in. Once again, watch the muscles in action in the lower arm. Find which directions they run in and observe what they do as you clench and unclench the fist. Then hold up your arm in front of you and examine how the muscles of the upper arm move as you open and close your fist. Finally, move the supinator radii longus (identified in Study 1) and your fist will rotate.

Study 5 Notice that in the three drawings of this middle-aged woman's hand, the muscles are less well developed, the skin quality is more wrinkled, and the veins more prominent.

Study 6 Compare this drawing of the hand of a 10-year-old girl to the man's hand in a similar position in Study 3, and to the drawings of the woman's hands. Notice how few creases occur in the skin at the wrist and finger joints.

31

The hand: holding, gripping, catching

The previous pages showed clearly that experience shows itself in our hands as much as in our physical features or personality. The models for all the drawings on these pages were young people, not yet fully physically developed. In the study of anatomy, this is both a help and a hindrance. It is a help in as much as we have a blank canvas on which to see the marks, movements and shadows caused by the muscles; a hindrance in that understandably many of the muscles are not fully developed. However, in these drawings (which were made with colored pencils) the former is more important as we are looking at quite subtle changes of movement. Changes that I can find in my hand – only because I know them to be there – are for the most part disguised by broken fingers, damaged muscle structure and the wear and tear of 40 years.

Study 1 Try rolling up your sleeve and, holding something gently (a piece of scrunched-up paper in this drawing), point your fingers upwards. You will notice that most people, when holding something carefully in this position, do not use the small finger. Most obviously, because it is shorter than the other fingers, but also because it is the finger that we use the least (although James Bond, in one of Ian Fleming's books, chooses the small finger on his left hand when faced with having one of his fingers broken because that is the finger he thinks he uses least, and is inevitably surprised at how often it is used). Try holding various objects and work out why you use various combinations of fingers. If you have a friend or colleague who is a musician, ask him or her to repeat your exercises and you will immediately notice that the trained small finger becomes a much more versatile appendage.

Study 2 Turn your hand slightly – very slightly – and notice how the outline of the hand changes (in older hands this change can be dramatic). Now study the thumb. The thumb distinguishes primates such as human beings from other mammals in that we have muscles that enable us to move our thumb and fingers in opposition; this makes grasping possible.

Study 3 Again move your hand so that you can see more into the palm. Move your thumb backwards and forwards and watch how the muscles move. Put down the object in your hand and stretch your palm as wide as it will go. Once again move your thumb, and at the same time gently feel the fleshy part of the palm below your thumb. You may be able to feel a muscle that runs from the center of the wrist to the thumb. This is the flexor pollicis brevis. (Try holding your hand against the light and look for the shadow caused by it.) On the outside of this is the oppenens pollicis, which enables the thumb to oppose the other fingers. In this drawing it can be seen by a slight highlight below the curve at the base of the thumb.

Study 4 Now pick up an object which requires gripping, and turn your hand so that you can see into the palm. Look for the workings of the thumb, and at how the lines on the palm help to delineate the shape.

Study 5 Finally, hold both hands in a catching position and once again examine the workings of your thumbs. Then, with the help of a mirror, look at the outside of your hands in the same position. For an artist this is the more commonly seen view, so again waggle your fingers and examine where the movement comes from.

Comparative proportions of hands and feet

Many artists have difficulty drawing feet in proportion to the rest of the body. Next time you cut your toenails, take a long look at how the size of your hand compares to the size of your foot. As a rough guide, the length of your foot should be the same as the vertical measurement from the top of your head to your chin.

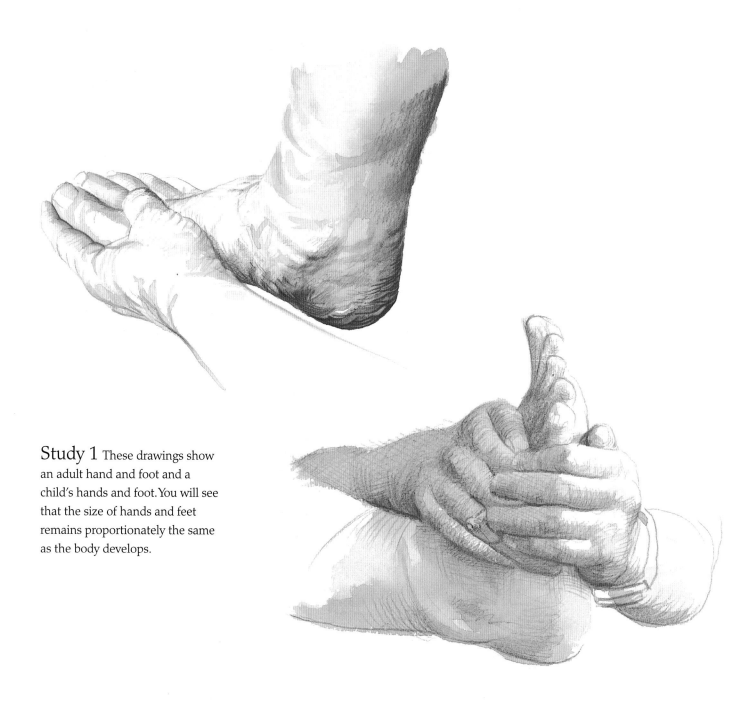

Study 1 These drawings show an adult hand and foot and a child's hands and foot. You will see that the size of hands and feet remains proportionately the same as the body develops.

Muscles of the lower leg

Understanding how the leg muscles control the foot is vital if your drawing and painting are going to have any veracity. The function of the lower limbs is to support the body and make walking possible. When you get ready for bed, take some time to walk around with your legs bare. Examine closely the working (moving) parts. Try to think about how you are making the muscle movements; with a bit of practice you should be able to feel how the whole leg works when you walk.

We regularly see people's hands, but Western convention (and climate) means that it is difficult to study people's legs and rare to be able to study feet. Like the hand, a foot carries the history of its owner with it.

Study 2 This shows the right foot supporting the body while the left is about to be lifted to take a step. The muscle which runs down the outside of the lower leg and which is so clearly delineated in the moving leg is called the peroneus longus. Its purpose is to flex and invert the foot and to support the arch. It also steadies the leg when standing on one foot. On the inside of the foot is a muscle called the tibialis posterior, which also supports the arch of the foot. This is a deep muscle which is quite difficult to see on the surface of the foot, however, an enlightened tutor at college once pointed out to me that if you always indicate its position in a drawing, the foot becomes much more life-like and when drawing for myself I do take his advice. In the standing foot in this drawing, the tibialis posterior is indicated curving from the anklebone to the sole.

Study 1 If you look closely at your leg, you will see that its structure is twisted. The first twist (inward) is between the upper part of the thigh and the knee. From the knee to the calf there is an outward twist, and from the calf to the ankles a further inward twist. If you stand on tiptoe, these twists will become quite obvious. This drawing shows a child standing on tiptoe, and the final inward twist to the lower leg is clearly seen in the line of the shadow.

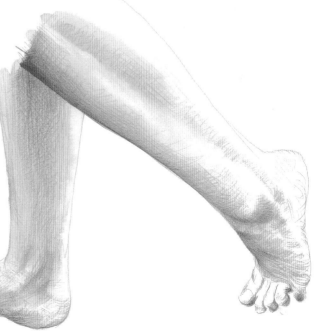

Muscles of the foot

There is no such thing as an 'ideal' foot, and it does not take very long for it to be altered, either by the whims of the fashion industry, or to suit a specialized purpose. Of the three youngsters who posed for many of the drawings in this book, one is a dancer, one a swimmer and the third expresses an ambition to be a painter, or maybe an actress. It would be interesting to see if you could tell which is which.

In recent times the most dramatic example of feet being adapted for specialized forms of living was to be found on the remote island of St. Kilda where, because life depended on the islanders' ability to climb the cliffs of the islands, the bone structure of their ankles changed, and their toes became more widely set and almost prehensile. Until the evacuation of the island in 1930, they were the only people in the United Kingdom who could be identified purely by seeing their feet!

These drawings were made with watercolor washes applied with a no 8 brush, and water-soluble pencils. You will be able to study your own feet in all the positions except one (Study 5).

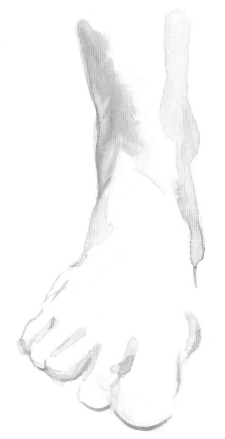

Study 1 The top of the foot has a strikingly triangular shape. This is caused primarily by the flexor digitorum longus, which splits into five sections at the ankle. This muscle is responsible for the flexation of the four smaller toes, the big toe being controlled by the flexor hallucis longus, which runs beside the flexor digitorum longus at this point. It will also be obvious that the triangular shape becomes less pronounced further down the foot as it flattens out. The sole of the foot is made of very thick skin and an underlying ligamentous sheath known as the plantor fascia.

Study 2 In this drawing, strong light is falling over the foot, clearly showing the ridges (tendons) of the extensor digitorum brevis. These obviously allow you to lift your four smaller toes; even without strong cross-light you should be able to see them in your foot. Feel how they move when you lift your toes. They run closer to the surface than the extensor digitorum longus, which causes the triangular shape at the top of the foot. It is also clear in this example that there is movement from the inside of the foot to the outside. This is caused by the extensor digitorum brevis, one part of which inserts into the big toe and the other three thin tendons onto the other three large toes.

Study 3 The lack of extensor digitorum brevis in the little toe is obvious in this drawing, as is the shape it gives to the foot. If you concentrate on the movement available to you in your foot you should be able to feel that the little toe is different in this respect.

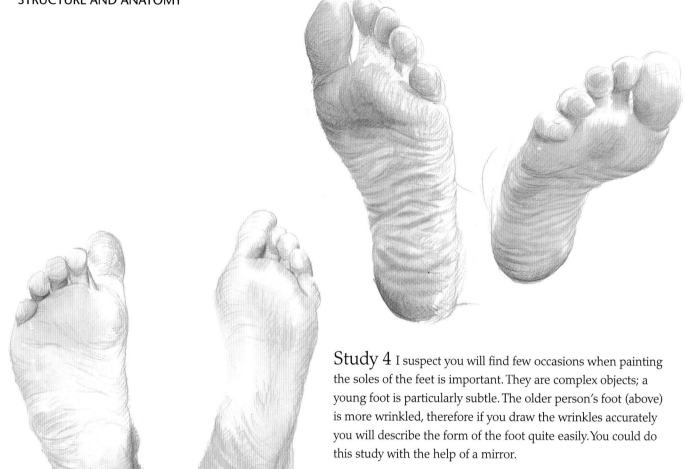

Study 4 I suspect you will find few occasions when painting the soles of the feet is important. They are complex objects; a young foot is particularly subtle. The older person's foot (above) is more wrinkled, therefore if you draw the wrinkles accurately you will describe the form of the foot quite easily. You could do this study with the help of a mirror.

Study 5 For this study you will need a model. The wrinkles on the sole curve up and round the side of the foot. The line of the extensor hallucis longus, the muscle which lifts the big toe, is visible as a highlight at the top of the ankle pointing at the toe. This muscle runs down the front of the leg. If you cup your heel into your palm and then run your hand up the back of your leg, you'll feel a strong tendon running into the back of the calf. This is the tendo calcaneus, or Achilles' tendon, which is the common anchor for the calf muscles, mainly the gastrocnemius and soleus muscles that give the calf its shape.

Study 6 At first glance this drawing may look similar to the previous study. Take a moment to compare them before reading on. The differences may be rather subtle, but they are there. The drawing in Study 5 is a view you can never get of your own foot. The drawing on this page represents the closest look possible at your own foot. Try to identify the extensor hallucis longus. This is hard because the higher lighting in this drawing doesn't cast any shadows on the top of the foot. You may be puzzled (indeed by now you should be puzzled) by the strange highlight on the lower base of the big toe. For this study, I was resting my foot on a wall, and the sole of the foot pushed the skin over the muscle surface and into the light, thus the emphasis.

Study 7 This is the view of feet that we are most used to seeing: the way they look from above. A drawing exercise on page 62 is based on this familiar view, so I will not go into any depth here. However, it is useful to try to identify all the muscles and tendons we have discussed up to now. Try adjusting the light and moving your toes. In this drawing the complexities are added to by the veins, which are very close to the surface. Do not let this distract you from drawing a foot with the correct muscle shapes. Use the raised lines that the veins produce to depict the foot's form even more accurately.

Study 8 The final drawing shows how easy it is to get the shape of the foot right if you take time to observe exactly where the muscles make shadows fall. Draw these accurately and the rest will automatically follow.

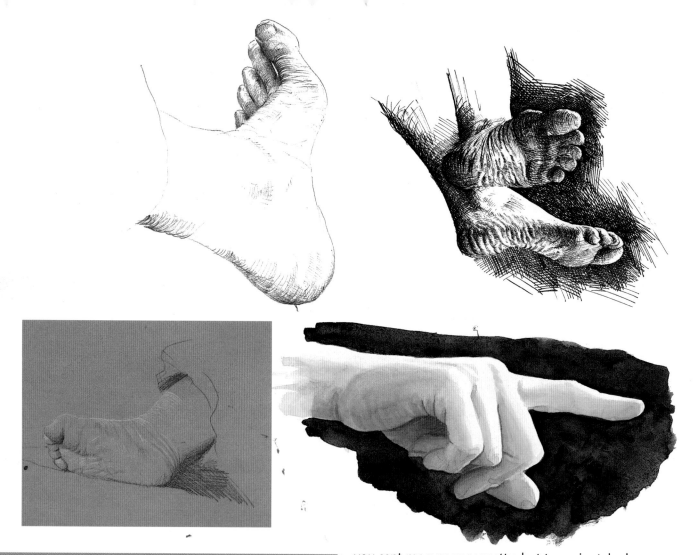

Drawing Exercises

you sent me was very pretty, but too minutely drawn. [Draw] thus with big strokes, boldly. Don't be frightened, make mistakes, as many as you like, but all the time draw very, very strongly anything you like, in…ink without using a pencil.' The young sculptor Henri Gaudier-Brzeska (1891–1915) wrote that to his youngest sister Renée, advice I can merely echo here.

If you are truly serious about your drawing, then friends and relations will start to wonder if you have succumbed to some strange compulsive disorder. Draw all the time, in anything, on anything, anywhere, all the time. If it is not convenient to others, or would upset

'As I've already advised you, don't draw anything except from nature. Draw branches now that there are no leaves, birds, the cat, particularly since he is so fat and beautiful according to Henriette. But for every drawing take a brand new sheet of folio paper. The little page

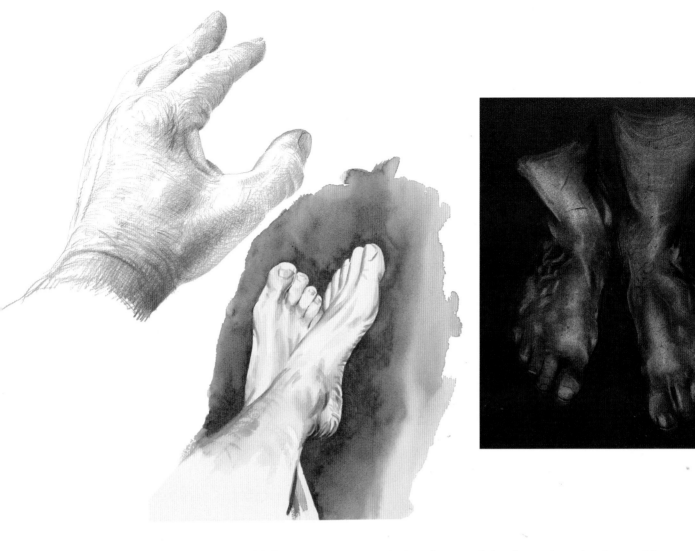

them, then *think* about how you would draw a particular image.

While I have suggested exercises and ideas, I have quite intentionally not given precise instructions for how I think you should draw or paint; you need to develop your own visual vocabulary. At the start of the twenty-first century, we are fortunate to be able to work with an accumulation of several thousand years of acquired knowledge. Teach yourself to use this, and remember that there really are no rules other than to be honest to yourself. Painters in the seventeenth or eighteenth century would have devoted hours to painting the snowflakes for a winter landscape. Now, thanks to the lessons learned from abstract expressionism, even a realist painter like Andrew Wyeth (b. 1917) depicts snow in his work using splashes of white paint. Be prepared to take similar bold action.

Almost all the drawings illustrating Chapters 1 and 2 were drawn at nearly life size (some were specifically drawn larger). There is no need for you to follow this example, indeed I would rather you scribbled down your ideas on the back of an envelope or in the margins of a newspaper than use the age-old excuse of not having the 'proper' materials at hand.

Drawing your drawing hand holding the pencil

Scribble-drawing

For these exercises you will need several sheets of white cartridge paper and a pencil – any pencil. But before you attempt a representation of the hand, consider how you hold your pencil.

Pick up your pencil and write your name, or draw an egg or any other simple imaginary thing. Do not concentrate on what you're drawing, but instead look at your hand as you draw and carefully study how you're holding the pencil. (There is no correct way to hold a pencil when you are drawing, although instruction in writing from early school days tends to

make us think there is, and that can be very restricting when it comes to drawing). Keep scribbling away, but now change the way you hold your pencil. You will notice three significant things: the line changes; the muscles in your hand change; and suddenly you are concentrating more on the marks you're making. Learn from this, and be prepared to constantly change how you hold the pencil.

Now move from observing your hand while you scribble to drawing your hand on paper.

Exercise 1 In three or four simple line drawings attempt to describe the hand that is drawing. This is quite difficult because the hand is moving and the 'outlines' of the form are constantly changing. The lines that you use will naturally, in nearly every case, start thick and finish thin and encroach into the figure.

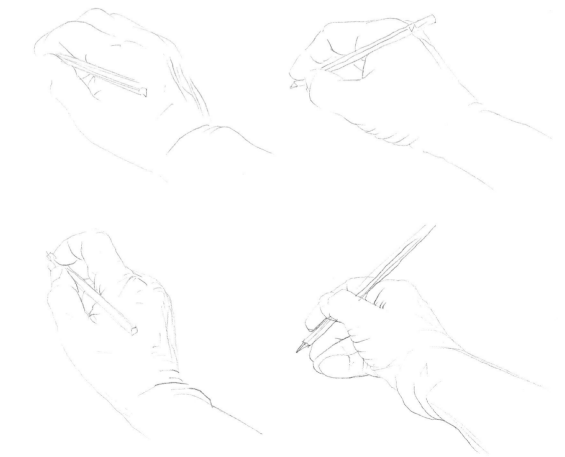

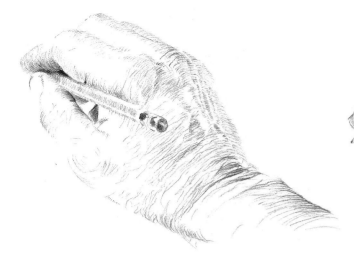

Exercise 2 If you compare the scribble drawings you made while studying your hand to your drawings of your hand, you will see that the former have a freedom and certainty that the latter drawings lack. The way to introduce this freedom into your academic drawing is to learn to scribble – controlled scribbling, that is. Look at your hand holding the pencil; look at the skin in the center of the wrist and consider which way a mark would have to be made to describe it. Make that mark, and without looking too closely at your drawing, scribble in the next line, working your way up the back of the hand towards the knuckles. Remember, light and shade will depend on how hard you press with your pencil.

Exercise 3 Start another drawing, using exactly the same technique. Flick pencil lines onto the paper which follow and describe the form. Notice where bones are close to the surface and try to devise a mark (sometimes it may be a complete absence of mark) to show that this surface is different from the rest. Do not bother with outlines at all; you will form them as you go along.

Exercise 4 Return to your initial line drawings and attempt to draw them again using the controlled scribble technique. By this time you will have discovered that it is only 'scribbling' in that the pencil rarely leaves the paper. Every mark is controlled and accurate, not only describing the shape of something, but also indicating from which direction the light is coming and whether the surface is soft or hard. This requires great concentration to begin with. Do you remember how hard you had to concentrate as a child when you were taught cursive writing? This is similar. Persevere, and before long you will be able to 'scribble' with great accuracy, and will rarely have to look at the paper.

43

Drawing your non-drawing hand

Developing scribble-drawing to a full study

For this exercise, which builds on the scribble-drawing exercises on the previous pages, you will need a few sheets of white cartridge paper and a colored pencil (or ideally, several of the same color, ready sharpened). Any color will do. I habitually work in brown, but have a colleague who constantly works in blues. Concentrate on your drawing, and if you find yourself planning the following day's shopping, then stop and put your drawing materials away.

While working on the drawings for this exercise the personal quality of hands was brought home to me once again. My left hand is not the ideal example of how a hand should look; however, by now you will have realized that I am more interested in producing work of some veracity than I am in a Renaissance ideal.

The sculptor Brancusi once wrote that 'it is the hand that thinks and follows the thought of the matter,' a philosophy echoed by Barbara Hepworth, who described her left hand as her thinking hand. Perhaps this is what makes sculptors' drawings different from those of painters: we have only the one hand to think with *and* to form 'the thought'.

Exercise 1 Place your non-drawing hand (if you are a sculptor, your 'thinking hand') on the paper, and quickly scribble-draw it.

Exercise 2 Start again. Scribble-draw the hand, taking no more than three minutes. Look more closely, analyse what you are seeing, and explain your analysis by making marks on the paper (don't be too influenced by my own drawing). Make the marks follow the direction of the form; you should have no straight lines. This is not easy, and indeed I hadn't realized how battered and claw-like my left hand has become until I did these drawings. Keep your pencil marks light in the areas that are well lit and press harder when drawing the parts in shadow (remember the egg-drawing exercise on page 14).

Exercise 3 Now move your hand slightly and repeat Exercise 2. You will notice how even the slightest movement causes massive muscular change. The ganglion between my thumb and index finger and the scar tissue on my index finger are particularly obvious in this view.

Exercise 4 Hold onto the side of your drawing board or sketchbook and once again observe the changes in your hand. I habitually work standing at a table with the drawing board horizontal in front of me; if you prefer standing at an easel, then the view you have of your hand will be very different. If you are sitting in a comfortable chair and working in a sketchbook, then your hand will actually be gripping hard to support the action of the other hand and it will again look very different.

Finally, move your hand slightly – very slightly. I slipped the two outside fingers around the edge of the drawing board, thus widening the gap between the thumb and index finger. Work a scribble-drawing up into a final full study.

Drawing your non-drawing hand pointing and with clenched fist

Pen and ink studies

For this exercise you will need a dip pen fitted with a pointed flexible nib, a bottle of ink, six small plastic dishes or bottles and plenty of cartridge paper.

The flexible pen was first used for writing copperplate script. If you have undergone the arduous apprenticeship of learning to write with one of these pens you will be at an advantage when it comes to drawing. If not, you may need to practice with it first, and if you are using a brand new nib you will find that it will take an hour or two to become worn in, so don't worry if your initial attempts are scratchy. The pen is capable of great subtlety, but it is totally unforgiving. Be positive, and do not be afraid to make mistakes.

Working with diluted ink will break you in gently to using pen and ink, and will also result in an effective range of tones. To prepare a graduated series of inks, put a couple drops in each of your plastic containers. Fill the first with water, three-quarter fill the second, half-fill the third, quarter-fill the fourth, add a drop or two to the fifth, and top off the last with more ink.

Exercise 1 Use the most diluted of the ink mixes. Hold your non-drawing hand in front of you with your index finger pointing, and draw using easy flowing lines, always working from the inside of the form. As in pencil drawing, do not make an outline to work within, let the outline arrive by the sum of your internal lines.

Exercise 2 Slightly twist your arm and start again. This time use two or more of your ink mixes to enable you to draw even more deeply into the shadow areas. To make a thinner line, turn your pen so that you are drawing with the back of the nib. Use both sorts of line in your drawing.

Exercise 3 Clench your fist. Draw it with the first three of the ink mixes. Take particular care with the wrist. Much of the tension in a clenched fist is obvious in the wrist and the knuckle area.

Exercise 4 Move your fist slightly and draw it again. Work quickly and readily, making sure each line that you draw is of some importance, each one working to describe the form of the hand or the direction a muscle or tendon is running. Try to make your lines vary by turning the pen and pressing with more, or less pressure.

Exercise 5 Turn your fist so that the inside of your wrist faces you. Again, quickly and simply draw what you see and what you feel. All five of these drawings should be done within a quarter of an hour.

Exercise 6 Hide the previous drawings and embark on a series of more detailed studies using the same poses. Work from the inside as before, ensuring that every line is thought about and placed accurately. Line may be lost in the well-lit areas, and emphasized in the shadow areas. Use the veins in the wrist to help explain how the underside of the wrist turns from a flat surface to a rounded one over the palm. Run a finger over the underside of your wrist and up into the center of your palm, and notice how the sensation differs. Can you get this into your drawings?

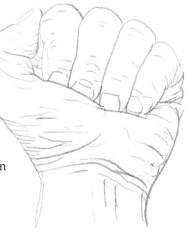

Drawing adults' hands

Brush drawing

For this exercise, you'll need a sheet of cartridge paper and a sable brush (the drawings illustrated here were done using a no 6 brush) and several bottles of colored ink. Alternatively try using food coloring – it is much cheaper than ink, does not contain shellac or any other brush-harming ingredient, is water-soluble, and is actually what I used in order to make these drawings.

You will also need a model, though it is not necessary to ask someone to pose for you. Try drawing someone's hands as they sit and watch a favorite TV program. This has the advantage of forcing you to work quickly and therefore look accurately, and it will also mean that the hands you are drawing are in a natural position.

The important thing to remember while working through this exercises is that nature does not have outlines. You will have noticed that there are several themes running through this book, and that is definitely one them.

For these drawings, I used the same models I used for the first 5 studies of hands on pages 30–31. You may find it interesting to compare my use of different media to portray the same subject.

Exercise 1 Using diluted black ink, or black food coloring mixed with an equal amount of water, load your brush. And I *mean* load – have the color dripping off the end of the brush. Look long and hard at the hands of your victim, and then quickly block in the broad areas of shadow. Dry with a hairdryer. Now using just the tip of your brush, draw in the obvious lines that indicate form. These will appear as contours around the wrist, knuckle and finger bones. If your model is elderly, there will be lots more contours. Having done this, let the drawing dry again and make a judgement as to whether your first wash was strong enough. If it wasn't, strengthen it now. Continue to build up the form of the hands in this manner, leaving untouched any surface that catches the light.

Exercise 2 Keep the model in the same position and move so that you see a different view of his or her hands. Start again using the same technique: a quick wash over the shadow areas, followed by drawing in all the lines that show the hands' form. This time, though, try particularly hard to show where the bones are close to the surface. It is especially obvious in an adult's hand that the lines and wrinkles that indicate movement flow in two different ways: wrinkles, for the most part, curve around the form, but muscles and tendons move along the form, as is most obvious in the hand in shadow in this drawing. To indicate this movement, make sure your lines do the same. I used black and blue food dye mixed together in equal measure for this study.

Exercise 3 Move your model into a strong light, mix a further variation of ink or food coloring and begin another drawing. The strong light throws everything into stark contrast. Look and work heavily into the areas in shadow, and don't touch those the light catches. It is possible the light will make the model's hands stand out strongly from a dark background. Don't be tempted to draw the line between lit hand and dark background. Notice in this drawing that the hand in the light has no descriptive lines beyond the one indicating the tendon leading to the third finger. Indeed there are only three lines describing the back of the hand. The brain is highly adept at filling in information; you should save yourself time and work and utilize this facility.

Exercise 4 This one is for fun. Food coloring comes in a wonderful array of colors, so try mixing them and experiment. I find the yellow available in my supermarket particularly exciting, although it does give hands and feet a jaundiced look!

Drawing a baby's hand

Silverpoint

For this exercise you will need a series of very hard pencils, nothing softer than a 4H, and a silverpoint. To make a silverpoint you will need a piece of fine silver wire and something to hold it in (see page 18). Alternatively, get hold of an old silver knife, fork or spoon (you will find that a look around second-hand shops or garage sales can pay dividends) and cut this down with a small hacksaw and sharpen it on a piece of sandpaper. Making a silverpoint in this way will mean you do not have to mount it in a holder as you will have to do if you use the traditional wire.

Silverpoint requires specially prepared paper. The paper I used for the example on this page was covered in white gouache when it was stretched.

Silverpoint is, to my mind, the ideal medium for capturing the fine quality of a baby's hand. Although the lines made by the silver wire are incredibly delicate, you will find that you can build up layer upon layer of silver, producing an increasingly deepening tonal range. If you get to a point where the deposit of silver is not deepening on the paper, then roughen the surface with a quick burst of hairspray. This dries to give a slightly rough surface and you will then be able to carry on darkening your drawing (although 'darkening' is a relative term when talking about silverpoint).

Exercise 1 The most obvious thing about babies' hands is their size (or, to be more accurate, their lack of size) and the rounded softness of the forms. Drawing an adult's and a baby's hand together will help you to observe this with greater understanding. This drawing is executed entirely in silverpoint.

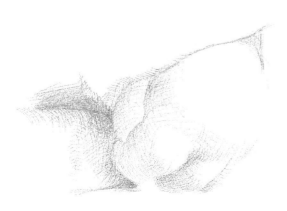

Exercise 2 You will notice that newborn babies often curl their fingers around their thumb. If you require a still model then this will probably be the only pose you'll get. It is not easy to convey the fragility of a baby's hand; keep your lines smooth and use as few as you can to describe the form.

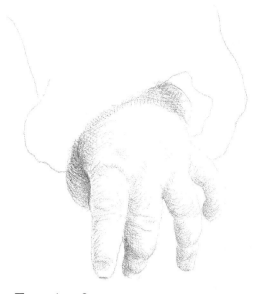

Exercise 3 These two drawings were made while the child was being fed. She constantly opened and closed her hand during the process, and I tried to time my observation with the opening and closing, and my drawing with the moments in between. Notice that the knuckle is not as pronounced as in a child's or an adult's hand, and that the fingers are more rounded. I finished up the drawing of the open hand with an 8H pencil after my model had fallen asleep.

Exercise 4 This is the obvious continuation to the previous drawing – child asleep with her fingers in her mouth!

Exercise 5 When you have a model, I suggest you do lots of sketches very rapidly, with each drawing concentrating on a different aspect of your sitter. You cannot expect a baby to sit still, so you will have to change your working methods to suit him or her. This drawing was completed using numerous sketchbook drawings after my model had retired for the night. It was begun in silverpoint and then worked further in the shadow areas with an 8H pencil. These were then worked even further with a 6H and further again with a 4H. A drawing of considerable detail can be produced using this technique if boredom does not set in first!

Drawing children's hands

Watercolor sketches

Children's hands can be extraordinarily flexible. While compiling this book I drew many youngsters who could do all sorts of weird and wonderful things with their hands and feet, and indeed for a time I planned to include a page of nothing else. On looking through my sketchbook, however, I concluded that if I were to do so, I would run the danger of confusing the reader and giving the impression that I couldn't draw. The one example on this page will have to suffice.

Speed is essential when working with children. I find that I work much more quickly with a brush than with a pencil, and watercolor sketches enable me to gather far more accurate information than I can with pencil and color notes.

In Exercise 3 I introduce you to one of my preferred ways of starting a watercolor sketch: by making an initial drawing with clear water. This enables you to make the drawing correct and to apply color in a way so that it blends subtly into the white paper without creating edges.

You'll need a box of watercolors, a no. 8 sable brush, watercolor paper and a patient or easily bribed model for the following exercises. (I used three different models for these poses.)

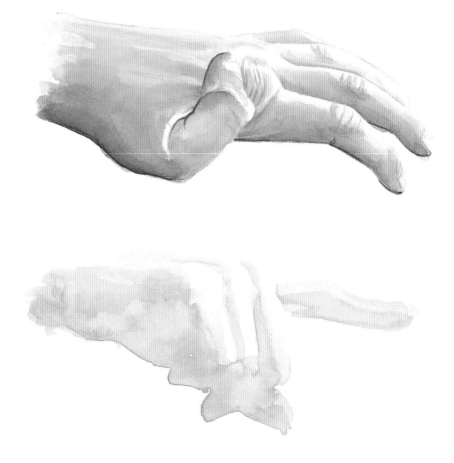

Exercise 1 It is remarkably difficult to draw something which appears to go against everything you have learned. Concentration and thoughtful drawing are required. After all, what you're drawing is patently possible (for someone with a double-jointed thumb) and your job is to work out why and how.

Exercise 2 Ask your model to point at something and then, using a thin wash of Naples yellow and cadmium red, sketch in the hand in no more than two minutes. Do not draw lines where the light catches the surface, only sketch in the shadow areas. The result is all that's necessary in a sketchbook drawing. It tells you the color, position, anatomy, direction of light and sex of the model.

Exercise 3 Completing the preceding drawing so quickly will have excited your model with the prospect of freedom waving merrily over the horizon. Renegotiate your terms and start again. This time, make the initial drawing with nothing but fresh water. When you are sure this is correct, flood the 'water drawing' with your paint mixture. Dry the areas that the light is catching with a piece of absorbent paper towel and quickly repeat the first wash, add a spot more cadmium red and draw in the shadow under the palm, and before this has dried add a small amount of sepia and continue to draw in the darker shadows. Let your drawing dry or attack it with a hairdryer, then, using the color mixed on your palette, draw in the darker lines to delineate the fingers. I would choose to leave it like this, but you may wish to bring the top of the hand into firm focus by adding a dark wash around the outline as demonstrated.

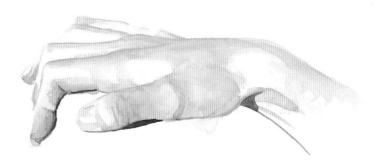

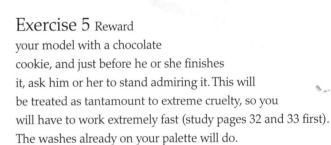

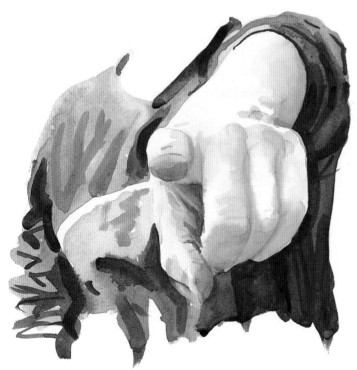

Exercise 5 Reward your model with a chocolate cookie, and just before he or she finishes it, ask him or her to stand admiring it. This will be treated as tantamount to extreme cruelty, so you will have to work extremely fast (study pages 32 and 33 first). The washes already on your palette will do.

Exercise 4 The first two exercises should have taken you about 10 minutes' painting time (and maybe half an hour of negotiating), so before you begin to lose the moral high ground, ask your model to point accusingly in your face (he or she will love this). The perspective of the arm is acute, and it will be very difficult to make it work. Ignore it and concentrate on the hand. Try to find some way of making the index finger leap out of the paper. (Remember that warm colors advance and cool colors recede.)

Exercise 6 Finally, ask your model to sit with his or her hand at rest and draw a relaxed portrait concentrating on how the fingers join the top of the hand and how the hand joins the wrist.

Drawing your own hand in oblique light

Charcoal and enlarging the scale

For this exercise you will need a supply of charcoal, some fixative or hairspray (see page 13), a supply of paper and a spotlight or table light.

Painters like Andrea del Sarto (1486–1531) and Caravaggio (1573–1610) delighted in chiaroscuro, a term referring to the treatment of light and shade in painting. It can also refer to a drawing in black and white, so in many respects this is truly an exercise in chiaroscuro. In practical terms, this is one of the harder exercises in the book because you will find yourself working in semi-darkness. However, there is a vast amount to be learned by studying the hand in a harsh cross-light, and I urge you to give it a try.

Many more lines can be seen in this hard light, which should make drawing the shape of the hand easier; however, at the same time oddly shaped shadows will be cast by the fingers and/or thumb which will make your drawing seem strange. Many years ago I was told by a wise (if highly cantankerous) professor of drawing that 'If it looks wrong, it is wrong.'

In this case you will have to look extremely hard to work out if it looks wrong. If it does look wrong, then correct it. Work with charcoal, and when your drawing becomes unworkable, spray it with hairspray and wait for it to dry. You will discover that you can now achieve a darker line when continuing to draw. This is because the spray's droplets harden on the paper, forming a surface like very fine sandpaper.

Up to this point all the drawings we have been making have been life-size or smaller. This is fine, but it is considerably harder to draw things larger than life, and we will explore this on the opposite page. Several Scottish art colleges used to introduce their first-year students to the life room by asking them to produce a life-size drawing of the model. For most, being faced with a nude model for the first time was daunting enough, but drawing on such a vast scale destroyed any belief in one's own ability. It showed with startling ease the paucity of one's graphic vocabulary.

Exercise 1 Set up a spotlight or a table light with its shade angled to cast light in one direction only. Switch off all other lighting. Hold your hand under the light and observe closely what you see. The parts in shadow will be in deep shadow, in places indistinguishable from the darkness of the background. If you have mastered the art of leaving out the lines catching the light, it will make sense now to blend these shadows into the background. Take a knife and sharpen your stick of charcoal, then begin to draw. As always, forget outlines. I began drawing at the base of the thumb and worked out from that point, ruthlessly leaving any part that was in the light untouched.

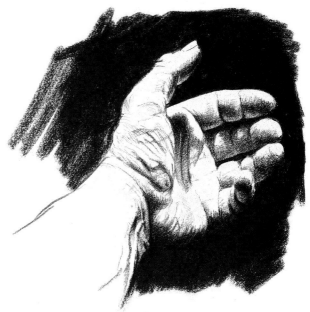

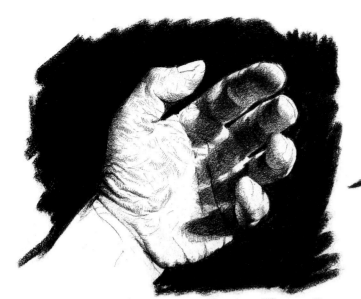

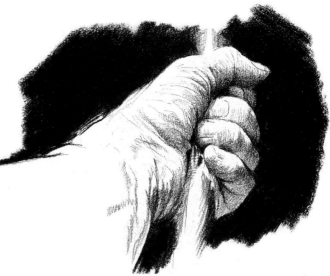

Exercise 2 Move your hand so that the fingers cause shadows to fall over the palm. Once again start to draw with a sharpened piece of charcoal. Make sure that the lines you draw describe the form you are trying to achieve. Although it is obviously impossible to make these lines as precise as you could with a pencil or crayon, your intention must be the same. Work as before from the center of the palm, allowing the outline of the hand to appear.

Exercise 3 Move your hand and grip on to an object. In these examples I am holding on to the towel rail. Clasp the object hard, and watch closely the muscles in the lower arm. By now you will have a very clear idea of what you are seeing. Keep moving your arm until you find a muscle movement that you did not expect and draw that position as quickly as you can, using your charcoal to describe to yourself exactly what it is that you are seeing and exactly what the muscle does.

Exercise 4 I want you now to think about drawing on a larger scale, but first, make a drawing of your hand life-size, as I did. Now move your hand into a different position and draw it at least half as big again. If you do not move your hand you will automatically replicate marks made in the first drawing and that destroys the purpose of the exercise. Changing the pose and the scale will challenge you to produce something different, helping you to understand better what you are doing.

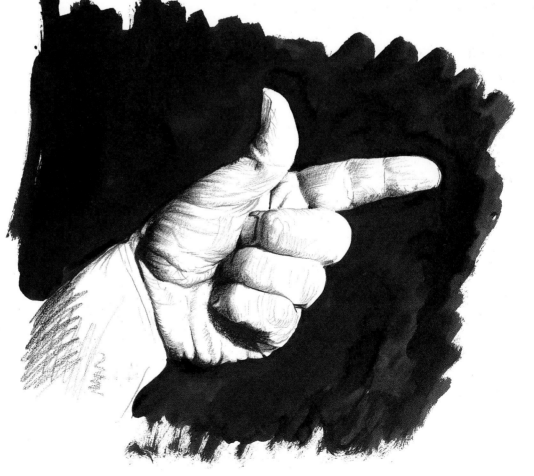

Hands: the ultimate exercise

Distortion and perspective

If you found the last exercise difficult, then this one will take you to a completely new level of difficulty – both as model and artist. Holding the pose hurts, the views are unfamiliar and you will have to work quickly with both your drawing hand and your non-drawing hand. Here, observation is pushed to the limit.

I cannot remember where I came across this exercise, but suspect that it (like the egg-drawing exercise) was a Renaissance apprentice test piece. You can use any media you like, although I counsel you to avoid anything that you cannot use with complete freedom. I used charcoal, pencil, ink washes and a brush.

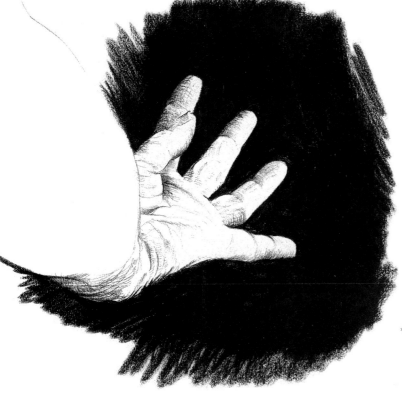

Exercise 2 Now turn your wrist in the opposite direction (clockwise, unless you are double-jointed) and again draw what you can see.

Exercise 1 With your non-drawing arm (for me, my left) fully stretched in front of you at eye level, hold your hand away from you with your palm upwards. Rotate your wrist counter-clockwise and bend your palm as far as it will go. Look down your arm and draw what you see. Notice how the muscle structure of the arm always moves into the wrist and never stays as an outline.

Exercise 3 Nothing too difficult there you may think, but now continue to turn your palm clockwise until the palm points up again (yes it does go). The muscle structure in the lower arm is very contorted, and the hand will be in a perspective and a position in which it is rarely, if ever, seen. Draw what you can see. Notice that the muscle which forms the left 'outline' in the arm crosses right over to form the 'outline' in the wrist. You will be able to feel the muscles that operate the thumb protesting at being asked to do a similar cross-over on the underside of the wrist. Draw quickly what you see and then have a rest. (I went to feed the pig at this point, but if you do not have such an excuse for resting just make yourself a cup of coffee.)

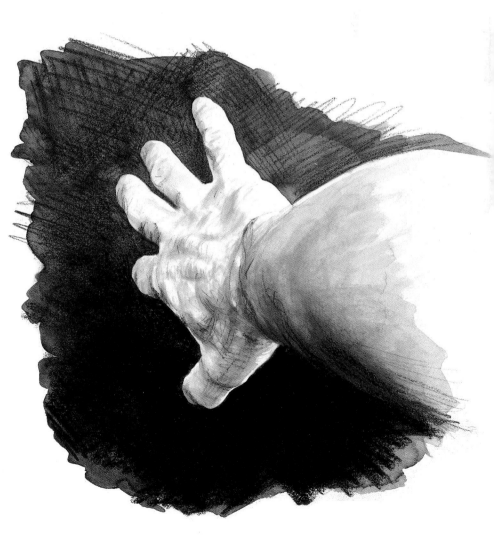

Exercise 4 (*Above*) When you return to work, hold your drawing hand across your mouth (it should just tickle your nose) and look down your arm. Draw what you see (yes, you will have to use your other hand, or the 'thinking' hand). Do not be confused by what you think you know of perspective, or by what you think a camera might see. Just draw what you can see. Do not bother with outlines. If you look at this example you will see that the brushstrokes describing the knuckles extend beyond where any outline may be.

(*Right*) Take a rest and then start again on the same drawing, working as much as you can with the 'thinking' hand. Then change hands and start to work on this drawing with your drawing hand, working from memory, taking up the pose from time to time and remembering what you saw.

Drawing your own feet

Wash drawings with coffee and watercolor

Feet, like hands, tell a lot about their owners. I ask a tremendous amount from mine. They are crammed into hot sweaty Wellington boots, plastic, high-altitude mountaineering boots, open leather sandals and (very occasionally) nice leather shoes. They are asked to walk many miles in all climatic conditions. As a reward, I try not to confine them too much by going barefoot for long periods – this has led to the soles of my feet becoming very tough indeed. So, I will reiterate, there is nothing to be gained by copying these drawings – concentrate on drawing your own. But first, you will need to make yourself two cups of coffee: one strong and black, the other just as you like to drink it. You will also need watercolor paper and a no. 8 brush.

Exercise 1 Put one foot over the other and, using the black coffee and the brush, quickly sketch in the shadowy areas of the foot furthest away from you. Concentrate on blocking in the shadow areas. Remember that these are caused by the muscle, tendon and bone and if you draw them accurately you will immediately get the shape of the foot correct. As in previous exercises, work from inside the form, allowing the outline to materialize.

Exercise 2 Start again, this time adding the other foot and perhaps the leg as well. Remember that your leg tapers from thick to thin and, when seen in steep perspective, that will be emphasized.

Exercise 3 Start for a third time. By now you will have started to look quite closely at your feet. Again, quickly sketch in the feet as before, but take time to draw into the shadow areas. You will remember from the X-ray photographs (pages 26–27) that the outer anklebone is lower than the inner one; try to find a mark that enables the viewer of your drawing to know that this is a hard surface. This is a much more subtle thing to attempt in the foot, as so much of it is harder than the hand. In this drawing I found it fascinating trying to find a series of marks which indicated the different sorts of hardness of my anklebone and the pad of hard skin on my heels.

Exercise 4 Finally, try a complete study, and when it is complete spread all your drawings out on the floor. Sit back, drink the remains of your own coffee (if it is cold then you have been working far too slowly), and study your work. You should have four drawings which increase in complexity and in the information they provide.

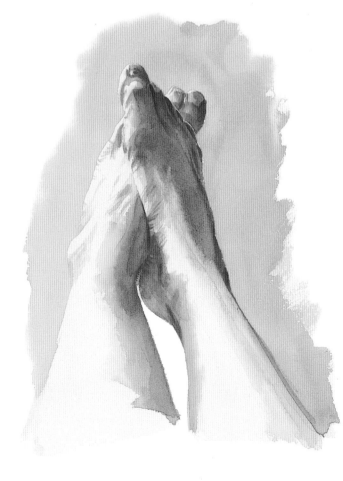

Exercise 5 At this point switch to drawing with watercolor. Put your feet up on a stool or chair again and cross your feet as shown. Take time to study them by sight and touch. Move the toes and identify muscle movement; try using a low side-light to dramatically pick out these movements. Then with a brush full of clear water, draw the shape of the foot (do not use a pencil first). If you do not get it right, let the paper dry and have another go. This time (still just using water) concentrate on the shadow areas and only draw the foot furthest from you. By the time you have this blocked in, the areas on which the light is falling will be nearly dry. Take a medium mix of color and drop it into the wet (shadow) areas. Work quickly and sketch in the direction of movement that you studied so closely. Let this dry, or dry it more quickly with a hairdryer. You should have achieved an even transition from dark to light, with no paint at all on the areas that the light is catching. Continue to work into the shadows. It is reasonable to leave the drawing like this, but I have taken a light wash of color around the outline.

Exercise 6 Change your feet around and repeat the exercise, but this time continue until you have a complete understanding of what makes your foot work. Concentrate on the middle of the form; forget the outline except where it is important.

Drawing your own foot resting on your knee

Thinking with a ball-point pen

If you have read the introduction to this book you will know that I do not like ball-point pens; however, it does tend to be the drawing implement that most of us have readily at hand. These exercises use nothing more than a ball-point pen and a scrap of paper and can be carried out almost anywhere. The second drawing of this series was done while carrying on an extremely boring conversation on the telephone. Drawing like this, although seemingly simple and relaxed, actually requires a lot of thinking. While writing the notes for these exercises I found myself constantly using words like 'describe' and 'explain', and this is what you have to do. Use your pen to have a conversation with yourself.

Exercise 1

Sit comfortably with your foot resting on your knee. Study the foot for a few moments and then – without looking at the paper – draw it. Do not take your pen from the paper unless you are extremely confident. This (like the egg-drawing exercise on page 14) should be practiced several times.

Exercise 2
When you feel quite confident about what you are doing, take the latest of your series of drawings a stage further. When you have completed a drawing (without looking at it), look down at what you have produced, study your foot and begin to correct the initial drawing's deficiencies. If you do not shave your legs you will find that drawing in the hairs accurately will produce the shape of your leg. Look hard for the bones, look at the lines of muscle and, if necessary, move a toe or two to check what it is that you are drawing. Concentrate. (Although as I have already admitted, I wasn't concentrating totally – but the drawing was much more interesting than the gentleman who was trying to impress on me the value of having an additional telephone line.)

Exercise 3

When drawing hands we experimented with controlled scribbling (page 42). In some ways the ball-point pen is the ideal tool with which to practice this art. Attempt a scribble drawing of your foot.

Exercise 4

Move your foot slightly but stay seated comfortably. Look closely at your foot, decide what is the most important line, and draw that. From this beginning start to scribble in the rest of the foot. Look closely and, as before, wiggle a toe now and then just to confirm you know what you are drawing. When you have the rough form of the foot scribbled in, start to describe the foot by drawing the lines you can see. If you are under 16 these will be few, but even they, if drawn accurately, will explain the shape of the foot. Try another drawing of the same position with the other foot, trying to simplify it by using the information gained from the first attempt.

Exercise 5

Finally, move your foot so that you can see its sole. This is very much the business end of the foot and to be honest, you will rarely have to draw it. As we already know, the tarsal and metatarsal bones form the two arches of the foot which, along with the thick fatty tissue of the sole, cushion all the shocks caused by walking. The outside skin takes considerable punishment and will be full of wrinkles. The secret is to draw these wrinkles as accurately as you can. As always, ignore the outside line, allowing it to develop. This drawing would be improved by taking away the line defining the upper part of the foot from big toe to ankle.

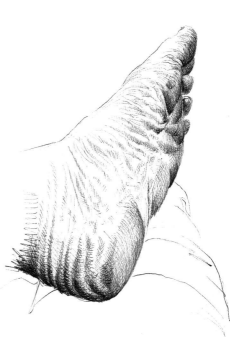

Drawing your own feet when standing

Working in reverse with charcoal

Up until now you have worked into the shadows, leaving the highlights to look after themselves. In this exercise, you'll be working in reverse, but the basic premise of ignoring perceived outlines remains the same.

To prepare, start by rubbing a stick of charcoal (any type will do) on a piece of sandpaper held over your drawing paper and when you have a reasonable pile of charcoal dust, rub it into the paper with your fingers. Rub very gently to begin with and work all over the paper, aiming to produce an even covering. At first, this will be a mucky gray, but continue rubbing until you

have a deep velvety black. When this is done, cut a rubber or putty eraser into triangles, each side of the triangle about 1cm (½in) long. Finally, cut yourself a slice of bread, the fresher the better.

The more astute readers will have noticed that this is the first mention I have made of erasers. You should never use them except when working with this technique. They contribute to a weak and hazy drawing style. You should not be afraid to make mistakes and your final drawing should be a summation of all your thinking (or, if you prefer, of all your mistakes).

Exercise 1 Stand looking down at your bare feet. Take the weight off one foot and watch how the top of the load-bearing foot twitches for a moment or two as it helps distribute the new load. Take a piece of bread and roll it into a ball, kneading it until it is soft, moist and malleable, then form it into a chisel shape. Using your bread 'eraser', draw into the rich black paper, removing all the highlights first, and then work out from them. Be bold and work on a broad front. After a while the piece of bread will become black and unusable, so discard it in favor of a fresh piece, but this time form it into a point. This will enable you to draw more detail, pick out the toes and possibly make marks to indicate the anklebones. Eventually this will become too cumbersome a tool; you will have to use one of your customized erasers. Compared to the bread, this is a precise tool that will enable you to make sharp clean lines to indicate tendons and veins. Every mark you make should describe the form of the foot. Although it was not my intention when I started the drawing, I felt the need to make some hard, sharp, dark lines and used a dip pen with undiluted Indian ink for those.

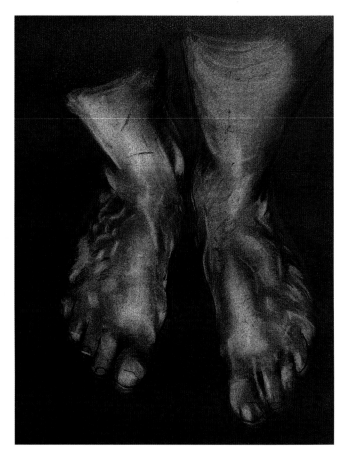

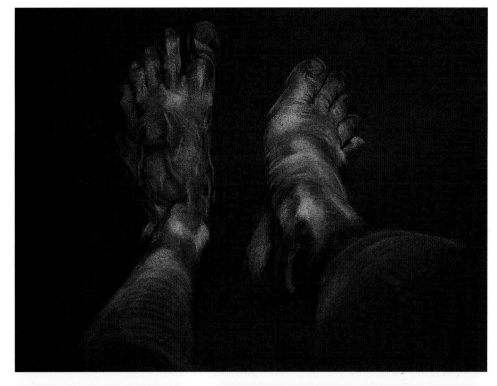

Exercise 2 Take the weight off one foot and start another drawing. This time the anklebone will be very pronounced on the relaxed foot, and there should be a noticeable tension in the foot that is taking all your weight. Compare this to your previous drawing.

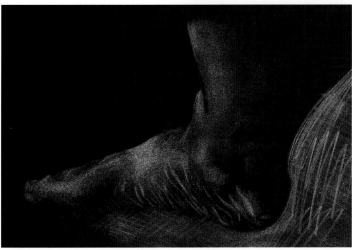

Exercise 3 Sit down, cross your legs and turn the foot that is not resting on the floor on its side. Notice as you do so where you feel the muscles move in the leg. Move your foot up and down and watch where the tibia joins bones of the foot. Choose a position that you find interesting and draw it using the same method. Ideally, you should do a series of drawings showing the movements of the foot.

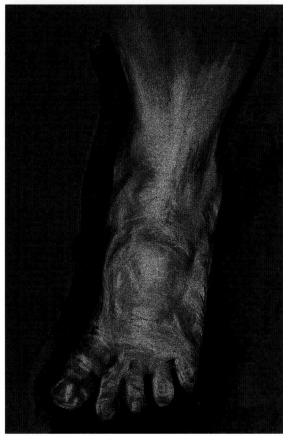

Exercise 4 Finally, attempt a study of your foot while standing on tiptoe. When I completed this example I tidied up the outline with a wash of undiluted Indian ink.

Walking

Capturing movement with wash and line

These are the only exercises in the book that require serious speed. The act of walking is a smooth elastic movement and as soon as it is interrupted, for instance, to ask your model to hold a position, the muscles change subtly. They look different while expanding and contracting than they do at rest or when holding a position. Capturing this flow of movement is very difficult and may require you to play around with your drawing and painting techniques until you find one that enables you to achieve the result you wish. I have used a technique I appreciated in the late drawings of the sculptor, Auguste Rodin (1840–1917). He was passionately interested in capturing the movement of a group of Cambodian dancers and worked with a flowing pencil line which was then corrected by a wash of watercolor (or vice versa). This gives the advantage of having two bites of the cherry, and produces an overlapping image that gives the illusion of movement.

For these exercises you will need a supply of paper (the examples are on a mediumweight NOT watercolor paper) watercolor paint, a no. 8 brush, a colored pencil and a graphite pencil. You will also require a very patient model.

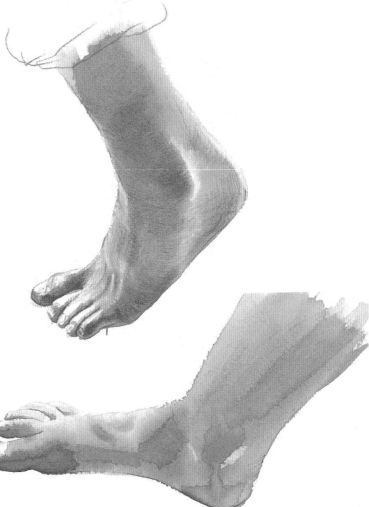

Exercise 1 Mix up a wash of color (I used cadmium red and Naples yellow). Ask your model to walk about in front of you for a moment or two. Watch closely for any idiosyncrasies of movement. Then ask the model to repeat, and when it is the rear foot, watch how it lifts to take a step forward. Start a drawing using a brush and wash, but only work on it immediately after your model has moved. With practice, you can quickly work into a neat rhythm with your model walking slowly in front of you: looking closely at the near foot and then drawing as the model continues with the step. By the time you are ready to look again your model has returned to a similar position. Work very quickly, and make up a series of marks with the brush that explains the movement you are studying. I added some colored pencil marks at this stage to correct and define the form.

Exercise 2 Now repeat the process but with the foot furthest from you, this time when it is in the act of taking the body's weight as it steps forward. Keep the wash drawing simple and decisive, and then use a graphite line to emphasize or correct areas.

Exercise 3 While you have been drawing these studies you may have noticed that your model has an unusual way of walking – everybody has some quirk or another. Make a couple of studies of this. The model for the examples shown here twists his ankle out as he takes a step forward. (He also has a webbed toe, but I have adapted this as I thought drawings of a four-toed foot in a book like this might be confusing.)

Exercise 4 Mix up more watercolor wash (any color). I have used a mix of cadmium red and Naples yellow because firstly it was already on the palette (incidentally a white dinner plate), and secondly because Naples yellow is not as transparent as many colors, and I wished the results to be quite strong, and I know that I have a tendency to make my sketches too subtle when working in this way. Ask your model to walk around slowly in front of you again, and make two or three sketches concentrating on simple application of the watercolor wash. No more than two or three brushstrokes are needed. As the model repeats the movement, correct the sketches with a lithe pencil line. (Remember those eggs!)

Exercise 5 Now for the difficult bit. Ask your model to walk around in front of you more naturally, and again choosing a foot, attempt three or four sketches and work on them simultaneously to describe its movement. Start with a simple wash of color placed accurately, moving swiftly from one drawing to another, then second time around correct the outline with your pencil in a concentrated dancing line.

Walking
Capturing movement in wash and line in more detail

You will need a sheet of paper, watercolor paint, a no. 8 brush and a selection of pencils the same color as the paint you choose to use. The more astute readers will notice that I am using a different paper from that used in the last exercise. I changed purely to force myself into concentrating. The last exercise involved very fast incisive work; these sketches couple that with more advanced observation, and I was anxious to ensure that the preliminary washes did not become purely clichéd marks.

The model for the drawings on the previous page was quite young. You may find these exercises of more benefit if you can find an older model.

The foot at rest is supported at three points. If you remember, the metatarsal bones are bent in a convex fashion, and if the body's weight is applied to them they behave like a spring, regaining the convex shape after the pressure has been removed. The arch of the foot is supported by several strong muscles, notably the anterior and posterior tibias, (the latter being the muscle mentioned on page 35, which I suggest you indicate even though you cannot see it), which prevent the leg being jolted when walking. The toes also behave like springs when the heel is raised.

Exercise 1 Ask your model to walk about in front of you and as before, look for any abnormalities in the feet. Take a brush full of watercolor (any color) and sketch in the prominent areas of shadow on both legs and feet. Do not fiddle: apply, leave alone, and allow to dry! Now take a colored pencil and draw into the watercolor. Look hard at the areas in shadow and ignore the areas that the light is catching. Use the lines that appear on the foot to indicate the shape, and vary them from dark to light. Perhaps the hardest thing to manage is making the anklebone look different from everything else. Try leaving it as the only pure white in the middle of the ankle. Notice that there is no line indicating the back of the lifted foot. A line is unnecessary because the eye makes it up.

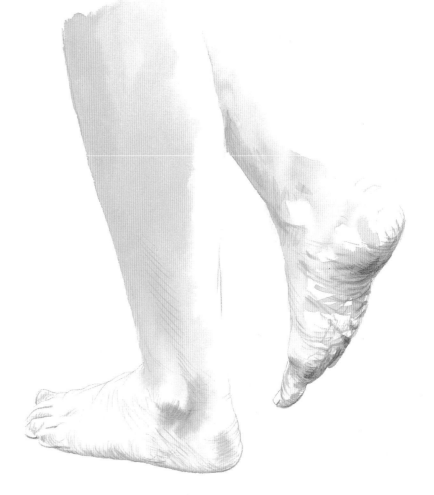

66

Exercise 2 This is a progression from the exercise on the previous page. Ask your model to walk in a circle in front of you and begin two drawings on the same sheet. Start with a foot and very quickly wash in the shadows that are cast on it. As the foot moves, repeat the process. You now have two very simplified feet side by side on the paper, showing a slight degree of movement. As your model walks around, keep watching the feet and concentrating on the movement in the ankle. As he or she returns to the position in front of you, wash in the rest of the leg, also concentrating on the shadows. Continue in this way, gradually working into the shadow areas with colored pencil and precisely applied watercolor marks. Take note of how the internal shapes change, particularly around the base of the toe.

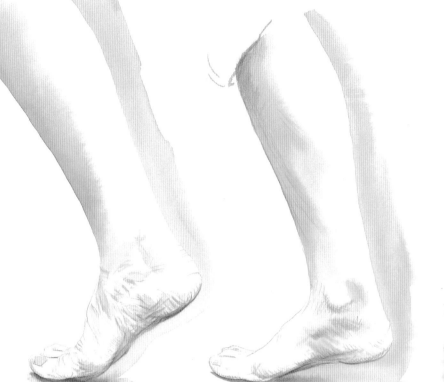

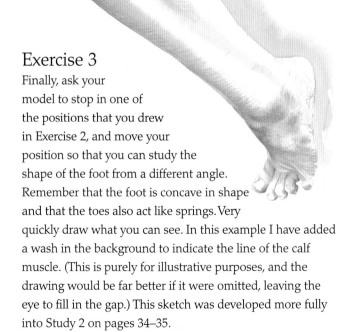

Exercise 3

Finally, ask your model to stop in one of the positions that you drew in Exercise 2, and move your position so that you can study the shape of the foot from a different angle. Remember that the foot is concave in shape and that the toes also act like springs. Very quickly draw what you can see. In this example I have added a wash in the background to indicate the line of the calf muscle. (This is purely for illustrative purposes, and the drawing would be far better if it were omitted, leaving the eye to fill in the gap.) This sketch was developed more fully into Study 2 on pages 34–35.

Exercise 4 Try a series of drawings showing your model from both sides and walking towards you and away from you.

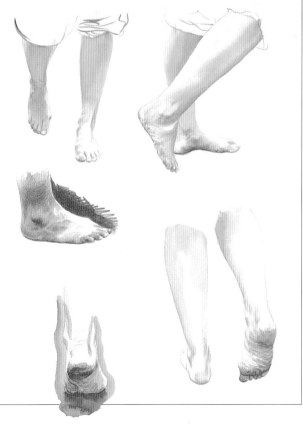

Drawing a baby's feet

Silverpoint

When discussing drawing a baby's hands, I introduced you to the use of a silverpoint (page 50). Its beautiful soft quality seemed so perfect for the study of babies that I decided to use it again. The difference this time is in the paper. As you will remember, silverpoint requires paper with a slightly rough texture, but this does not have to be white, nor does it have to be gouache. Here, I mixed up some acrylic paint and rubbed it into the stretched paper with my fingers in much the same way as the charcoal was rubbed into the paper for the exercises on page 62. You could just as well paint it on with a brush, but rubbing the color produces a less plastic look and gives a deeper quality to the paper.

The information about legs and feet that you will have worked out for yourself by now will hold you in good stead, but you still have to look very carefully indeed at your subject. You will find that the bones of a baby are very difficult to make out and that any formula you have already learned for 'marks to describe bones' is rendered obsolete! Finding marks to represent new muscle is also a major challenge. Babies' legs and feet must be made to look different from those you drew when studying a child or adult model.

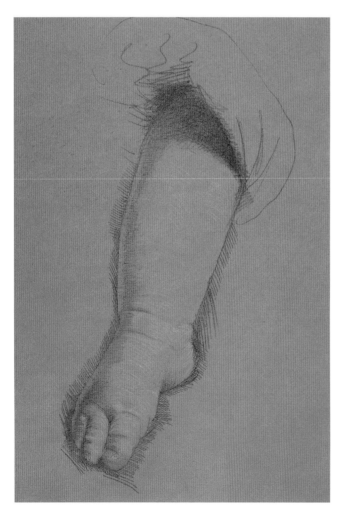

Exercise 1 This drawing was made while the model was feeding and her legs were relaxed. Notice that the arch in a baby's foot is not developed and is therefore flatter than that of a child or adult. There is also an amount of loose skin, which disguises both the skeletal structure and the muscle movements. Just a touch of white pencil has been used to add highlights to the silverpoint drawing. My model suffered a dislocation of the hip at birth and has worn a tiny brace for the past 13 weeks. These drawings were done in a brief burst of freedom before it was discarded for good.

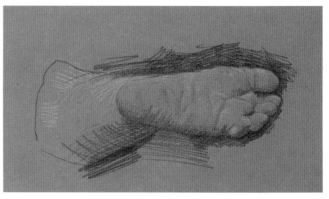

Exercise 2 The sole of a baby's foot is soft, and the only wrinkles are from loose skin. Compare this drawing to those on pages 36–37 and 72–73. You will have to find a way to indicate that the quality of the wrinkles is different.

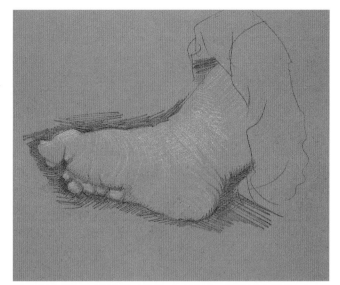

Exercise 3 Set yourself the goal of producing a series of explanatory drawings. Work on several simultaneously, aiming to complete perhaps only a couple. Silverpoint or a very hard pencil does not lend itself to lightning-fast sketching, so use them as you would a scalpel, with confident precision. Start a new drawing each time your model moves, and if he or she repeats a position then go back and complete that drawing.

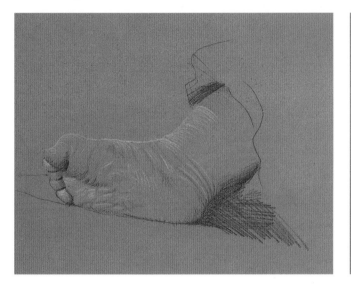

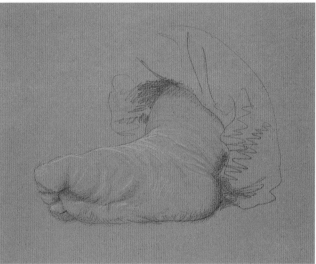

Exercise 4 Finally, make a drawing that sums up everything you have discovered by looking hard at your model's foot. Notice here how the lack of arch is strikingly obvious, how the anklebone is quite hard to detect, and how the bones of the foot are really only detectable by the soft fleshy side of the foot.

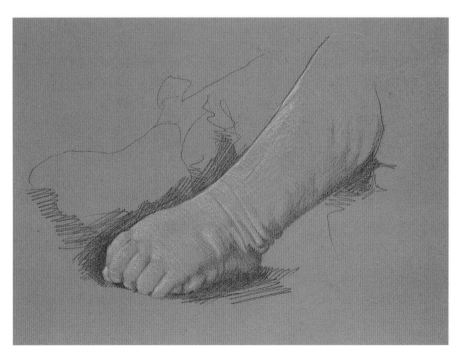

Drawing a child's foot

Line and wash drawings

The aim of this exercise is to bring together two of the approaches to drawing that we have already considered, through looking at the front and side view of a child's foot. Start with some quick pencil line drawings, each one gradually building up in complexity, and then make some drawings using ink wash. The two can then be combined to give fuller information about the subject.

Work quickly and start afresh when a line goes wrong – don't labor away at the same drawing. Remember, these sketches are for your benefit only, so it does not matter if they don't look right – simply start again, or correct your drawing

You will need a supply of paper, a 2B or 3B pencil, some ink, a no 8 brush, a piece of white chalk, as well as a willing model.

Exercise 1 With your model standing facing you and the main directional light from one side, try to capture the outline of the front of the foot and ankle with just a few lines. Take no more than a minute to do this – having to work quickly will make your line fluent.

Exercise 2 Do another sketch with some marks to indicate the roundness of the toes and ankle. Do three or four versions of this stage (not spending more than a minute on each).

Exercise 3 Before boredom sets in for your model, do a drawing in which you study more fully the shadows that lie along one side of the foot. Find marks to describe the shadows as they curve around the toes and the side of the foot. As a line moves out of shadow and into the light, release the pressure on the pencil to achieve a lighter, thinner line.

Exercise 4 Now change the pose and change the medium you are working in. Ask your model to stand side-on to the light source, with one foot in front of the other, and the weight of the body mainly on the front foot. You will notice that the arch flattens and the toes splay in the weight-bearing foot. Mix up some ink with water to create a pale wash, and using your brush, draw the shadow areas that you can see, and then develop the drawing.

Exercise 5 Ask your model to shift his/her weight onto the back foot and to lift the heel of the front foot. Notice in the front foot how both the shape of the arch and the position of the toes have changed. Make a quick sketch, defining the shadows and ignoring the areas where the light catches the subject. Finally, try to complete the drawing in a single sweep of dilute ink. This requires great concentration and a steady hand.

Exercise 6 Now return to the original pose, with the foot facing you and make some ink wash drawings. Your lines should, by now, be confident and fluid. Progressively add more layers of ink to the shadow areas. On your final drawing, once you are satisfied with the areas of shadow and light, use your pencil to add detail and make corrections with well-placed marks, and add highlights in white chalk.

Drawing an adult's feet

Pen and ink

I am afraid there is no hiding place with this exercise. The last time we used a dip pen with a flexible nib (page 46) we diluted the ink and this, for some reason, makes the marks seem less formidable and demanding of commitment. This time you are going to use the ink straight from the bottle (I used Indian ink). There is something almost frightening about sitting poised over a clean white sheet of paper with a pen fully loaded with glossy raven-black ink. The temptation is to make a few light pencil lines to act as a guide, but resist all such whispers.

Remember to turn the pen to vary the width of line and to not to press as hard when you require a light flow of ink. Nine times out of ten I encourage students to put things down on paper in the order they appear in nature: the background over-drawn (or over-painted) by the middle distance, which in turn can be overlaid with the foreground. This means that the ink (or paint) layers will physically imitate the thing you are trying to represent. This is not to say that this is the definitive way to draw a leg and foot. Indeed, if you study the drawings on these pages you will be able to work out the order in which the marks were made, and you will discover that the thinking differs each time.

Exercise 1 Ask your model to sit comfortably with legs crossed. Work out in your head just which lines you think will be necessary and which could be omitted, and which foot you should draw first. If you draw the foot furthest from you first you will need an extraordinary eye to be able to judge where to stop and leave a space for the upper foot. Then draw the upper foot in as few lines as you can manage. Your first mark with a fully loaded nib may well be over-strong. It will not take you too long to work out where I started this drawing! Indeed, if you look closely you will be able to work out the entire history of the drawing, and thus gain an insight into my thinking.

Exercise 2 Ask your model to cross his/her legs the other way. Try another drawing. Once again take your time to look closely before starting work, and once you start, do so with speedy deliberation.

Exercise 3 Ask the model to cross his/her legs in a position similar to the one in the first drawing, and straightaway begin a final study. By now your thinking will be clearer and you will have a firm idea of what went wrong in the first attempts. Note that in this example every line indicates the form of the foot.

Exercise 4 Sit down facing your model and look at the feet facing you. Like the child pointing on page 53, this view poses all sorts of problems in perspective, but once again ignore them and concentrate on drawing what you can see. If you can teach yourself to look accurately and to understand what you see, you will never need a mathematical understanding of perspective. From this viewpoint, the lower part of the upper leg describes the visible top of the lower leg. Try to explain to yourself what you are looking at with a simple line drawing. Work quickly and look hard.

Exercise 5 Working an ink drawing into a detailed study is not easy. If you over-work the piece, then obviously you will end up with a black sheet of paper. Keep the initial strokes free and wide apart, slowly closing them as the drawing proceeds. Do not resort to 'shading'; make every mark tell its own story.

Drawing feet on tiptoe

Working at speed

I have left this exercise to the end because, unless you happen to know a trained ballet dancer, this is one that will cause your model (and by extension you) the most problems. With a model standing on tiptoe you will naturally have to work quickly and decisively, which will test the powers of observation and knowledge that you have gained through these exercises; it will also make you find a way to express the forms and movement decisively and with simplicity. Use the medium that you are happiest working with – I have reverted to my preferred brush and watercolor for these studies.

When I had completed the study shown on this page, one of my students pointed out that I had drawn the legs in different colors. The model quickly pointed out to her with great disdain that she had been standing next to a large, freshly stretched canvas, and that it was obvious that the leg farthest from the window was being lit by reflected light from the canvas. If a ten-year-old can teach herself to be so observant, then so can you!

Exercise 1 Ask the model to stand on tiptoe with both feet on the ground and the light falling on the side of his or her legs. You will see immediately that the line between light and shadow on the leg and foot forms two curves. Draw these as quickly and as accurately as you can before your model begins to complain: ignore completely the side of the leg and foot that the light is hitting and concentrate on drawing the outer edge of the shadow area. Then draw the dark spaces between the toes. Quickly put in the shadows cast on the floor by the legs; these will define the side that is in full light. By this time your model will need a rest, so stop.

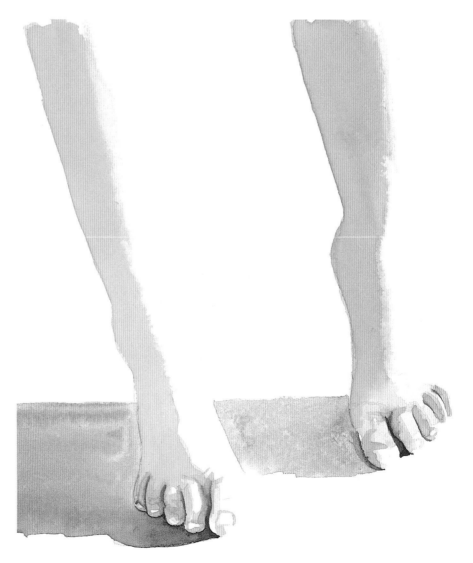

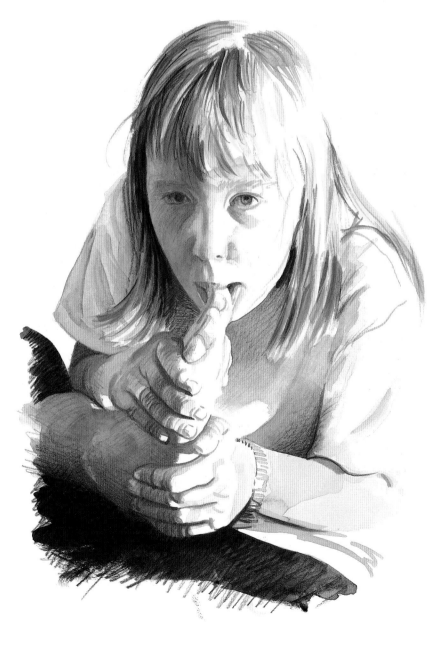

Exercise 2 Now ask the model to balance on tiptoe on one foot. To maintain a balance he or she may have to raise the other foot (my model is a fine dancer and has automatically curved her raised foot into a neat point). As in the previous exercise, first establish the line between light and shade; if you are working with a brush you should be able to establish the outer limits of the shadow at the same time. Once again work with all speed, and before the model falls over, indicate the toes.

The model for this drawing is the dancer on the opposite page. Here she neatly provides a 'footnote' to this chapter, showing the extraordinary flexibility of a child's limbs, and conveniently posing for me with both hands and feet.

Progressing to Painting

f positions were reversed and I were reading this book, this would be the first section to which I would turn. However, in creating it I realized that it doesn't give a true indication of how I work, for no painting ever splits itself into a given number of convenient stages. I don't believe painting should follow a formula, and if I know what the result of a painting is going to be,

then there is no point in making it. If I do not know what the final result is going to be, then stopping to photograph 'stages' becomes almost impossible, as the dialogue between the artist and the painting can swing backwards and forwards almost constantly. I have tried to make the following demonstrations as real as possible, but you should think of the stages illustrated as points that were 'aimed for' rather than as points that just happened. If I were to start any of these paintings again, the opening moves (like a game of chess) might be identical, but the challenges thrown up by them could be reacted to in a very different way, thus leading to a quite different result.

The watercolors are perhaps closest to my usual way of working, but even here there are no rules, and a work can be completed in one or a hundred stages. Oil paintings usually take me many months to complete, so here I have demonstrated two oil sketches, which were perforce completed in one sitting. I rarely use pastels or acrylics but have included works in these media here for a sense of completeness.

Obviously all the paintings illustrated make use of hands and feet, but the point of the exercises has been to allow you to observe and record them in a natural manner to fit with any portrait you choose. It is interesting to discover how many brilliant artists avoid having to paint or draw them. Pick up any art book and leaf through it – I guarantee that you will be pleasantly surprised at those artists who just happen to have their model hold a hat, or conveniently have their hands hidden behind something.

Hands are hugely expressive and are not difficult to paint if you forget the rules that constantly suggest that they are. I have a student who, when completing a large canvas last week, took courage and painted a hand into a compositionally critical space. It took 10 strokes of the brush and works perfectly. She is only 11 years old – I am sure you can do it as well!

1 Louisa practising her finger exercises

This painting stems from one of the happiest commissions I have ever undertaken. Louisa is a fine musician and for a time was definitely one of my favorite models. Her hands are an extraordinary mix of a child's combined with a trained musician's: wonderfully versatile, strong and mobile. My sketchbooks are full of her executing fast runs on the piano, but for the purposes of this portrait I thought it best to keep the movement of the hand to a minimum. The personal challenge in this drawing (apart from remembering a very enjoyable half-hour or so) was to catch Louisa concentrating, and to find a way to draw a white shirt against a strong light.

I am not at my happiest using pastels and usually add them to a watercolor underpainting, working on stretched watercolor paper as I have done here.

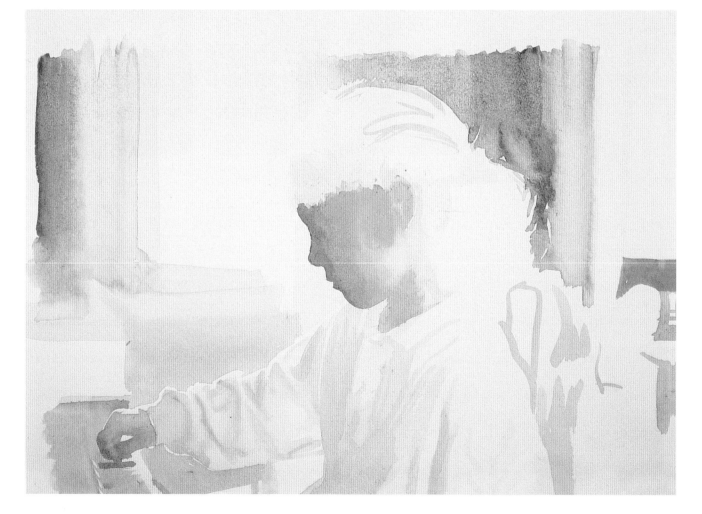

1 I quickly sketched in the primary composition leaving the paper white where the light was strongest. The background is Naples yellow and burnt sienna, the shadows on the shirt Naples yellow and Payne's gray. The head is a mix of all of these and is at this point purely intended as an underpainting.

2 The hair is now blocked in using sepia and burnt sienna, and I took great care to make sure that the highlights were left as white paper. If you look closely at many of Seurat's figures you will see that he paints a very subtle halo effect around them. This gives them a brilliant luminosity, and I attempted something very similar here. If you look closely at the following stages you will see that a thin line of white is kept around the forehead, nose, mouth and chin. This was accomplished at this early stage by simply leaving the line unpainted as I went over the background again with a wash of Naples yellow and yellow ochre. I also started to draw with pastel, particularly marking in the back of the shirt.

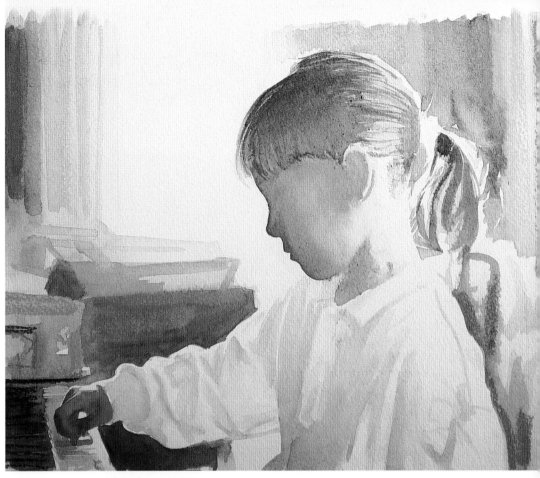

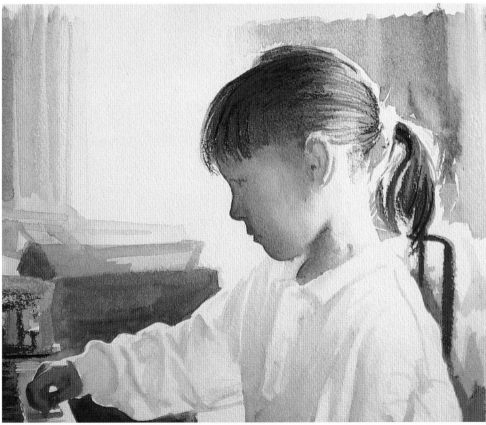

3 Although there was no need to aim for a likeness, the drawing would not be as personal a statement without it, so I drew in the eye and mouth aiming for a fair degree of veracity. If you look hard at a figure seen under strong backlighting it can be very difficult to work out exactly how the forms curve around the figure. It is important that you do not end up with a cardboard-looking silhouette.

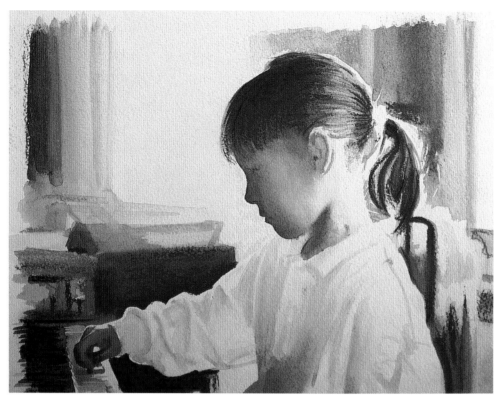

4 I used a dark brown pastel at the back of the figure and to make the arm reaching out to the piano stand out. This was rubbed in very hard. I also used it in the background to bring out the highlights in her hair. Earlier we discussed how a musician trains his or her fingers to be very precise tools. The exercises Louisa was working on form the basis of this training, and the position of her hand has to portray this.

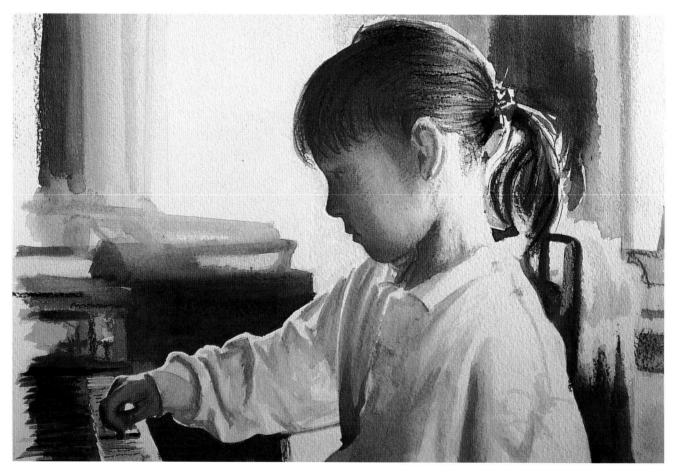

5 The entire background was darkened using a mixture of yellow and white pastels and blackboard chalk. I also worked on the neck using the same materials.

6 I then scribbled in a few lines of chalk to try and give the effect of the light catching the piano keyboard. The keyboard is of course reflecting light back on the underside of the hand; light which constantly flickers as the hand moves. The whole of the head was then drawn in a mixture of pastel and chalk. I had particular trouble with the area beside the ear, eventually getting it to sit correctly only when it was a good deal darker than I had first thought. One of the things often forgotten about underpainting is that it is not something that is only done at the start of a painting, but that is carried on until the picture is nearly complete. I applied some quite strong purple and red to the hair to make the dark brown and black I knew I was going to use next appear stronger.

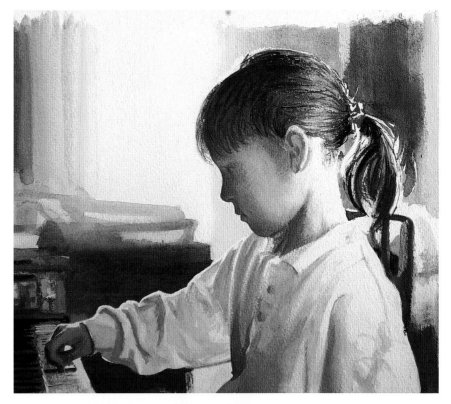

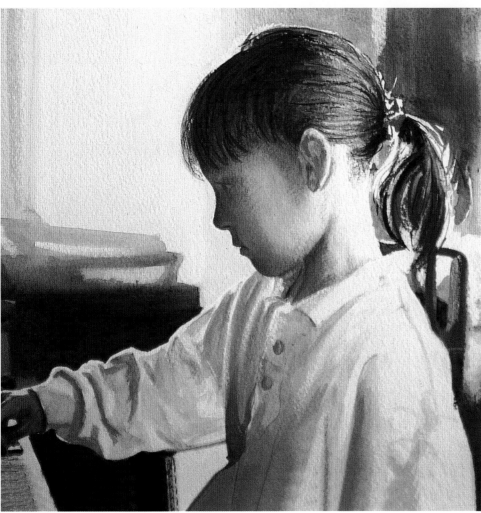

7 The darks mentioned above were added, making sure that the strokes described the shape of the head. Up to this point I had thought to use only the white of the paper to indicate the light flooding through the window. In watercolor painting, the white of the paper is always the strongest white available. Here, however, I decided to press pure white pastel and chalk into the paper.

Louisa practising her finger exercises

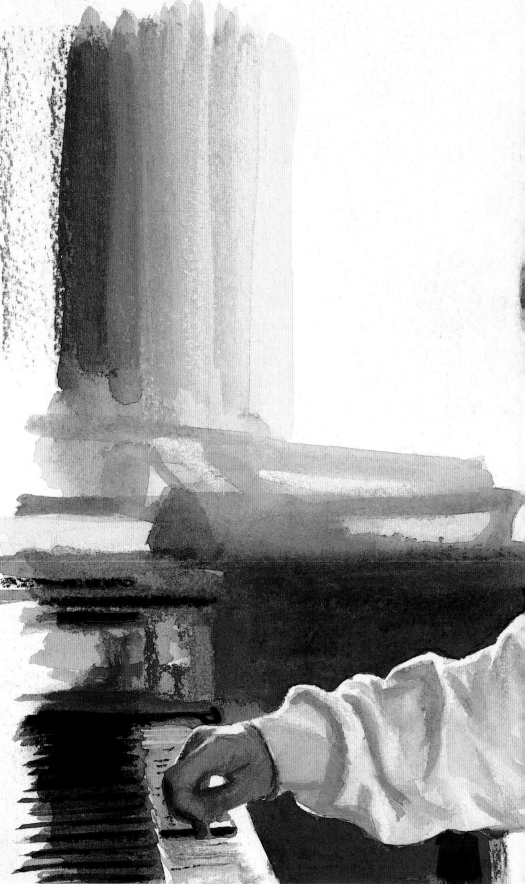

I completed the drawing by spraying the entire surface with hairspray to fix it, and once again rubbing white chalk into the window areas; I also took a knife and sharpened a piece of chalk so as to be able to emphasize the aforementioned line round the nose and mouth. I then sharpened a piece of charcoal and deepened the shadow of the finger actually depressing a key. A few dots and dashes of various colors helped complete the picture. As I write these notes, though, I wonder if it might be best to cut off a couple of inches at the right- hand side and thus bring the subject of the picture closer to the golden section and further from the center. I also like it the way it is! Perhaps it is not complete.

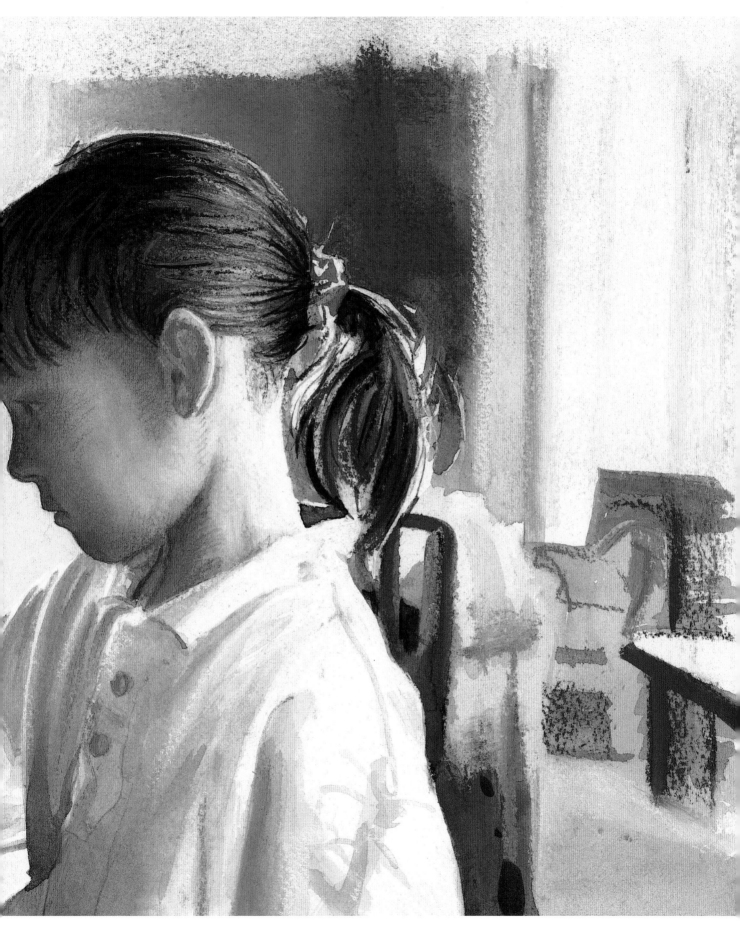

2 Jackie in Room 13

Room 13 is the studio in Caol Primary School, a studio run almost entirely by the students themselves. It has a very high aesthetic standard and constantly produces work that challenges adult perceptions of 'child art'. As an off-shoot of the studio, they also run their own art gallery, which has shown work by many of the country's leading artists. As part of the constant search for funds, the management team commissioned one of the younger artists to design a Christmas card, which was then printed in the studio and sold. The printing process was labor intensive and two printing teams worked in relay. Jackie was 'shop steward' for one team and her portrait was painted during her team's rest period.

Choosing a model is not easy. Sometimes, as with a commission, you will have no choice. Ideally, I look for someone whom I want to paint and who also wants to be painted by me. In this case Jackie had intrigued me for some time, seeming quietly self-contained and gently self-confident. The fact that she could keep the others in order from her perch on the window ledge without having to move took care of the second part of the 'ideal' equation. I think of this as a sketch. A completed painting would be worked from two or three such sketches and would not be done with the model on site. I knew this would be used in this book, so I asked her to take off her socks and shoes; this immediately produced a tremor of jealousy throughout the rest of the team – safety considerations insured that they kept theirs on!

1 As always when I start a watercolor, the initial drawing was done in water only. Once I was sure that this was correct, the head, hands and feet were sketched in with a wash of Naples yellow and cadmium red. The paper was then dried with a hairdryer and the body blocked in using a couple of washes of Payne's gray.

84

2 As the Payne's gray washes were drying I worked on the feet, making sure that I had the angles correct and that the shadow areas were going to be correctly drawn. When that was complete I returned to the jersey and washed in further sweeps of Payne's gray mixed with a little cobalt blue. I took care not to touch the passages across the subject's left shoulder on which light was falling.

3 The same mix that was used to establish the shadows on the jersey was then used to paint in the legs. If you look closely you will see that I have experimented with adding form to the leg. This was done with the firm knowledge that if I got it wrong it could be covered up at a later date. I then mixed a spot of sepia with burnt sienna and added the first strokes to the hair.

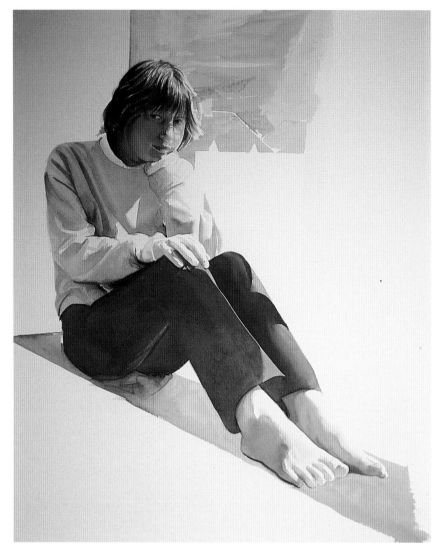

4 At this point work opened up on several fronts. Working very quickly with cadmium red and Naples yellow applied in roughly the same tone as before, the paper was tilted so that the color ran to the edge of her collar. A further deeper tone of the same mix was applied, and then a further one (though slightly more red). The cadmium red was mixed with a touch of cobalt blue, and this was dropped in.

I worked in roughly the same manner on the hands and feet, taking great care to work into the shadows and to leave everything caught by the light to the initial wash. Look hard at what you are painting. By now you should be able to work out quickly whether you are looking at muscle, tendon or bone, but if in doubt feel your own hand or foot to check. Feeling your model's foot will not necessarily help you, and at worst could be misinterpreted!

I added a wash of indigo to her pants, and while all this was drying I could move on to the background.

5 At first, I thought the painting would work quite nicely on a white surface, but as it progressed it became obvious that something else was required. (There was a certain amount of 'persuasion' from the students as well, with bets being placed on whether or not I could paint the reflections in the window.) Having been persuaded to rise to the bait I quickly blocked in the rest of the school buildings and the town in the background. It would have been very easy to become engrossed in this and thus neglect the portrait, so I attempted to keep it as free as possible. As soon as I painted in the window ledge on which Jackie was sitting I realized that the triangle that formed at the bottom left of the picture was going to be a problem.

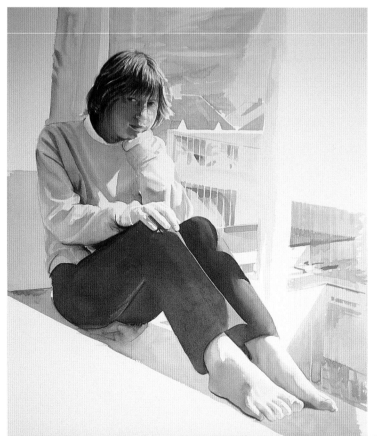

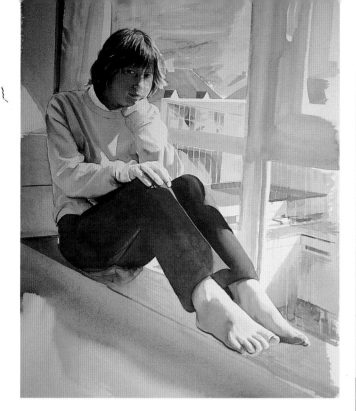

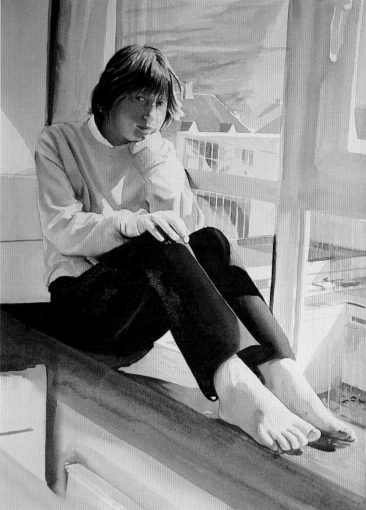

6 I hastily threw in the rest of the composition. I hoped for a moment or two that the triangle of light behind the shoulder might counterbalance the problem of the lower left-hand corner. With hindsight I can see this was bound to fail, but it is very easy to fool oneself.

7 Breaking up the triangle at the foot seemed a good idea ,and I brought down verticals from above the model and painted in the radiator. I then darkened the windowsill behind Jackie and worked for a while on the view out of the window. All this in an attempt to detract from the increasingly ugly corner.

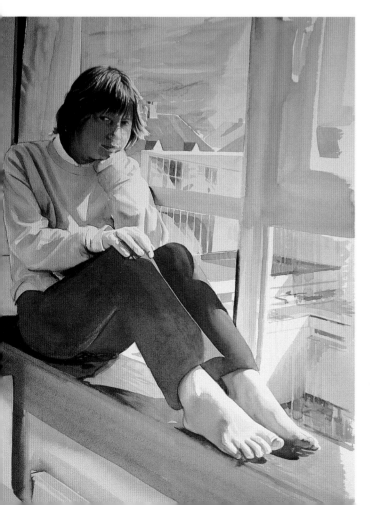

8 At this point it seemed wise to move back to the job in hand and I mixed up a little Payne's gray with some indigo and painted in the pants, leaving untouched all the areas on which light was falling. I played around with the notion of using the reflected light from a sink, which was showing on the outside of her knee.

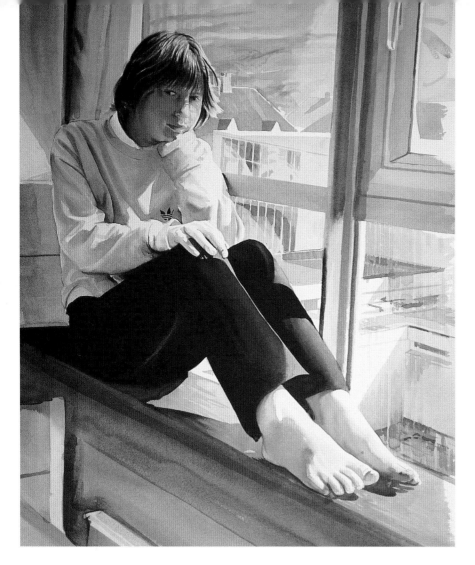

9 As soon as I left a line to indicate the reflected light, I changed my mind and added a further wash, which deepened the color of the pants and gave more subtlety to the figure.

10 At this stage, the core of the picture was complete but the background needed a lot of tightening up and the area under the windowsill was still wrong. I added depth to the shadow areas in the gray rectangle beside the foot with a mixture of Payne's gray and indigo, and decided that the reflections in the window needed to be darker, as did the rooves of the houses.

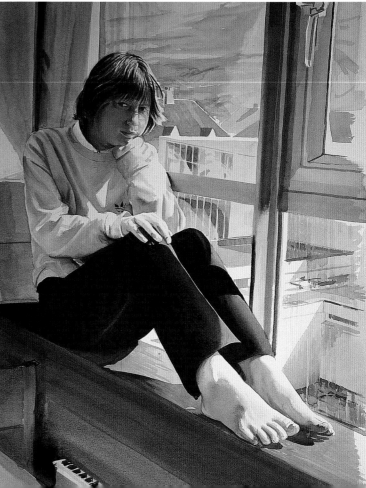

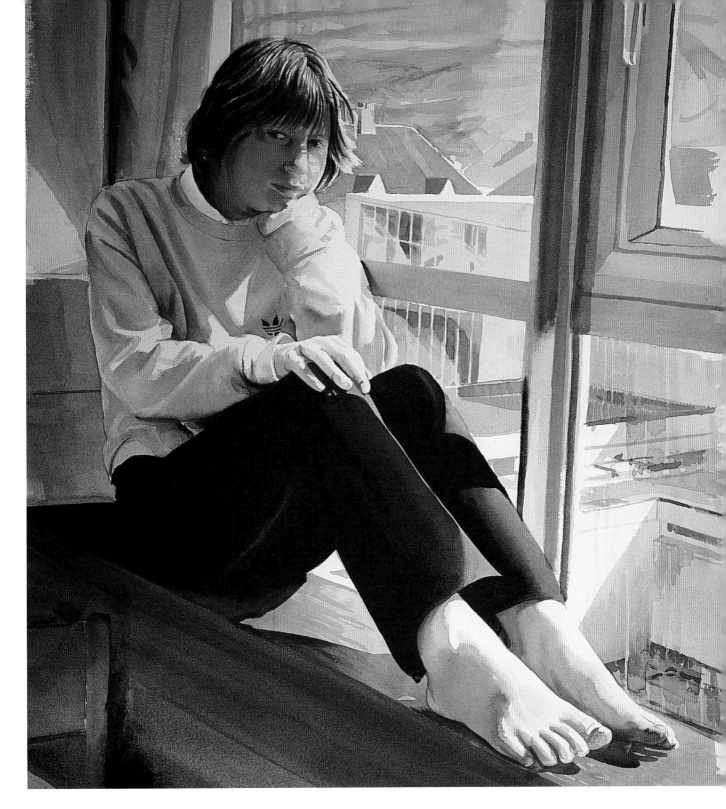

Jackie in Room 13

Before you complete a painting, it is important to review the image and make any necessary last-minute corrections. I tightened up one or two small areas, particularly the face, and darkened the hair around the right cheek. I also decided to soften the reflections by dabbing them all over with a damp sponge, and to strengthen the window frame with Payne's gray mixed with Naples yellow.

The area under the windowsill was still not right, so I loaded a large (10cm, 4in) decorator's brush with a mixture of viridian, alizarin crimson and indigo and made several broad strokes across the area in question. You shouldn't be afraid to use bold gestures even in the late stages of a painting. When I took the painting off the board, I concluded that the area was still not satisfactory and trimmed off the bottom of the sheet. This changed the proportion of the image and composition but kept the focus on Jackie.

3 Parbati

I have known Parbati for many years, and I paint her portrait every time I visit Kathmandu. Every portrait thus far has been informal and unposed until, on a recent visit, I suggested we do the job properly. She kindly sat at the entrance to her father's workshop while I produced five quick watercolor drawings. I intend to combine these into a tempera painting, which is a medium requiring much pre-planning. This watercolor is the first stage in that process. As we sat talking, in her excellent English and my appalling Nepali, she stroked a stray wisp of hair away from her eyes and rested her chin in the cup of her hand, pulling up her knees so as to be able to rest her elbow on them. The hand and arm were taking no weight, merely resting between chin and knee. If you look closely, you'll notice that the skin covering the muscles in use is a different color from that covering relaxed muscles. The way Parbati was sitting was a gloriously relaxed pose and will, I think, become the tempera image.

1 The painting is on a heavy (300gsm) paper with a NOT surface. After masking out highlights in the hair, on her bindi and on the earrings with masking fluid, I sketched in the head and hand with clean water. When this was roughly correct, I flooded the area with a mix of cadmium red, burnt sienna and Naples yellow using a 12mm (½in) decorator's brush and quickly soaked up the paint with a piece of absorbent paper in the areas where light was falling. Notice that at this early stage, I made little effort to separate the hand from the head.

2 Before the first 'wash' dried (I use the term loosely, as I don't apply the color in a traditional wash), I deepened the shadows, indicated the form of the mouth and added the part in the hair. I used the same paint I used before, thus avoiding the color bleeding back.

3 Ideally I would have continued with the paper still quite damp, but in photographing the last stage it dried out too much. Sometimes this can be fixed by spraying the painting with clean water, but if the paper becomes too dry then the spray sits on the surface rather than sinking in. I used the opportunity to draw in the line of the wrist and shoulder, sketch in the hair with cobalt blue; then more radical methods were called for. I dipped the entire painting in the bath, gently dabbed it dry with a dish towel and continued painting a thin mix of raw sienna on the forehead, and a stronger mix of cadmium red, Naples yellow and burnt sienna with a touch of cobalt blue to the shadow side of the mouth.

4 I then applied this mix to the jersey, leaving untouched the areas light was catching. I also added the mix to the forehead, which was becoming a problem because it was illuminated by a fair amount of reflected light on the far side. I wanted to emphasize this in the final painting, and many of the problems involved had to be addressed in this preparatory piece. Cobalt blue and cadmium red gave the T-shirt its color, and pure cobalt blue gave the underpainting for the deep shadows in the hair.

5 I used the purple mix to draw in the mouth and deepen the shadows on the jersey and in the hair. It was far too early to think about the detail on the jersey, but an idea occurred to me and it was easy to experiment with it knowing I could take it out later if it didn't work. I applied a thin mix of burnt sienna to the front of the forehead (which was still a concern) and used it to form the underpainting of the eyes. I wanted to keep them simple and liquid, so was aware of the need to keep the paint as transparent as possible. I also gently washed the mix into the shadow areas of the hand.

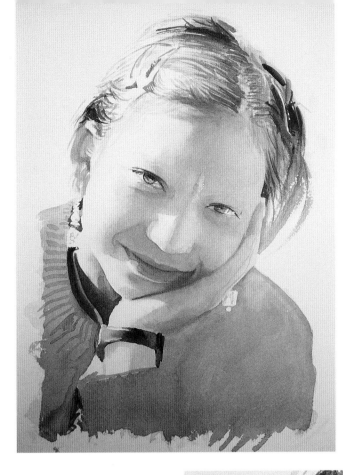

6 At this point, I added Payne's gray to the palette and described the hair more thoroughly. I added a small amount to the cadmium red, Naples yellow and burnt sienna mix to deepen the shadows between the hand and chin. I also used it to deepen the purple T-shirt and, in its pure state, to draw in the watch. Watches and bracelets are handy, as, if you draw them accurately, the shape describes the curve of the wrist without a lot of difficult and subtle painting. The hand, although a prime player in the composition, is left in a very freely painted state; to do otherwise would distract from the main purpose of the painting. The strong curve between her chin and hand is compositionally important. By the time I had completed this, the eyes were dry enough for a further touch of burnt sienna and now a small amount of yellow ochre. To give the illusion of reflected light on the forehead I had to be aware that it would also be reflected in the eyes. Finally, I deepened the jersey a bit more.

7 I gave a lot more thought to the jersey and the lips, using a mix of cadmium red, alizarin crimson and Payne's gray. By this point, the portrait was coming to life, and indeed, could be left as it is for a sketchbook painting.

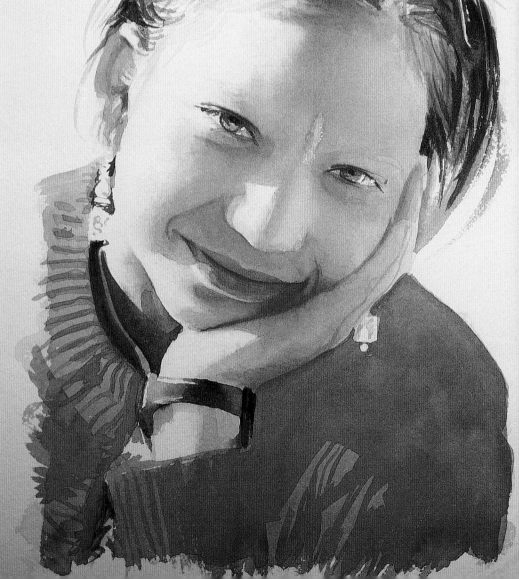

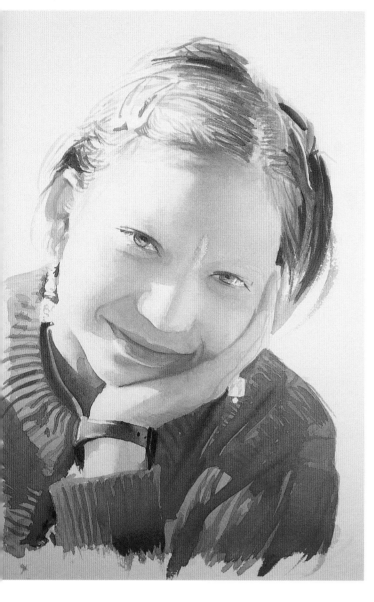

8 The jersey was now completely reworked, with much thought given to the direction of the pattern on the garment – I applied the same mix I used previously in bold fluid strokes. The forehead was still not quite right and so I applied a very, very thin wash of burnt sienna and yellow ochre to it. This was then carried down into the shadows around the eyes and into the shadows on the hand and under the mouth.

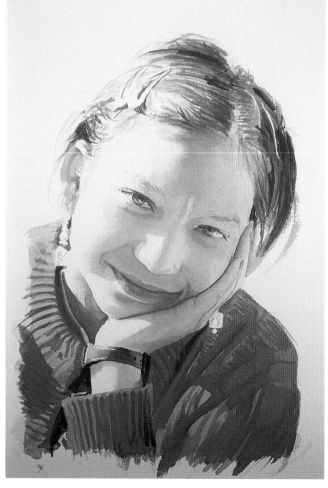

9 I have probably learned as much as I am going to at this point, and all that is left to do is to correct the mouth, fine tune the eyes and think about reworking the ear. You will see, if you look back, that the ear has slowly grown throughout the painting. At one time I considered using pure cadmium red to give the look of the sun shining through the thin skin, but decided against it.

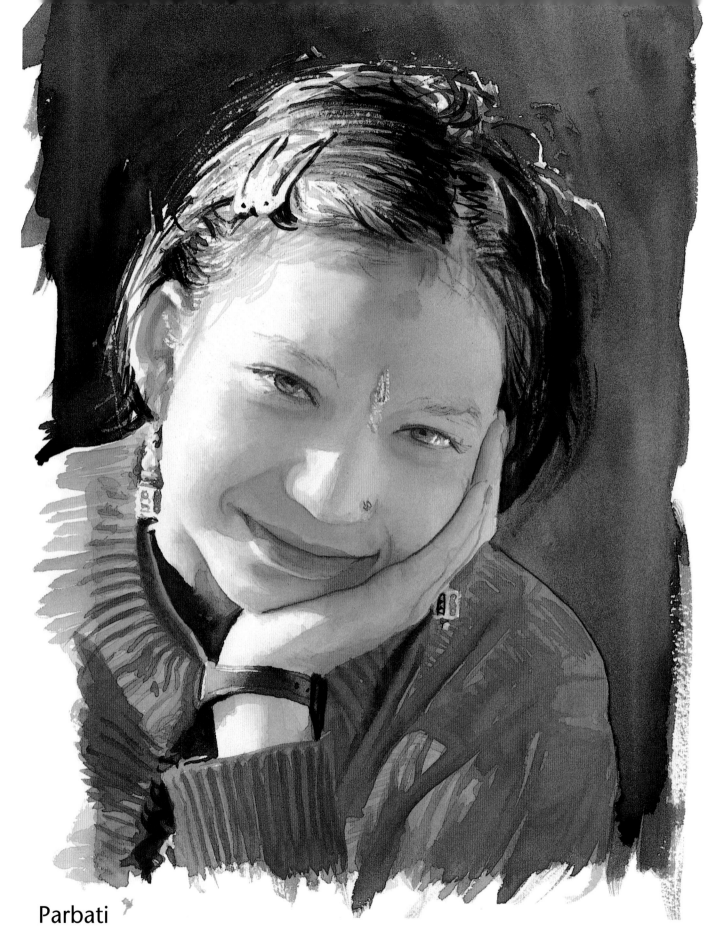

Parbati

All the masking fluid was removed finally, and the bits and pieces of jewellery were touched up.
As a final touch, I took a razor blade and scraped highlights into the hair and onto her nose ring.

4 Angela and Liam

This oil sketch is the result of a negotiation over modelling in which the honors were eventually even. Angela offered to model if I would paint a picture of her and her little brother as a present for her Mom. The composition of the piece also results from these negotiations. I thought that, because the painting was a present for Mom, it might be quite nice to have Angela drape a sisterly and protective arm round her brother. She stoutly refused, and I, therefore, refused to start the painting! I won, but this stand-off is the reason that the hand on Liam's shoulder is anything but relaxed.

The painting was made on a primed thin wooden panel using sable-type brushes. I rarely use the traditional oil hoghair brush, preferring decorator's brushes if I need to cover a large area. I used nos 8 and 10 sable-type brushes and a 12mm (½in) decorator's brush in the making of this picture.

1 Once the negotiations over the composition were out of the way I sketched in the vague outlines using a predominantly blue palette – Payne's gray, cobalt blue, and a touch of cadmium red. When painting tempera portraits I usually underpaint the flesh tones in green and had thought to do so here; however, as the painting progressed I rapidly realized that it was going to be completed in one sitting. The main interest from my point of view was the strong light streaming through the windows which lit Angela and Liam's faces with an exciting reflected light.

2 Cadmium red and Naples yellow were used to block in the skin tones and some areas of the computer terminals in the background. You will see that only basic modelling has taken place and that the paint is applied thinly and quickly. Even at this early stage I anticipated having problems with Liam's legs and feet and only went as far as establishing the limits of his shirt.

3 I then spent a few moments working on the heads and hands. The usual Naples yellow and cadmium red were diluted with a touch of titanium white, and I concentrated on making sure I understood how the reflected light was going to compete with the direct light.

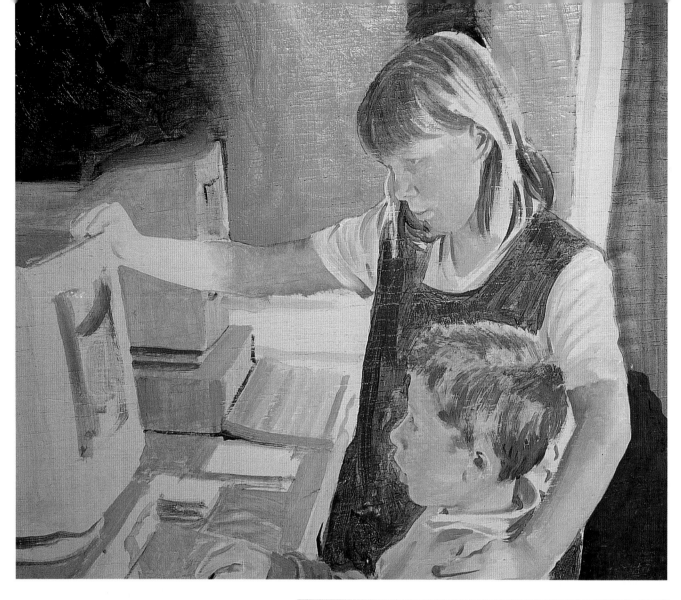

4 As white had been introduced to the scheme of things, I worked on the wall in the background, establishing the pattern of shadow, which I suspected would play an important part in the final picture. I also continued to work on the faces. The shadows in the hair were indicated by a few marks of sepia and Payne's gray. Normally a likeness would be of secondary importance, but the small print of the contract with Angela stated that this was a prerequisite. A small amount of cadmium yellow was added to the cobalt blue to enable her tunic to be brought into the correct tonal range.

5 Having painted in the tunic, I almost immediately decided that the color was wrong and changed it. At this point the models departed for a break, and I amused myself by indicating the various odds and ends on the table and working out how to represent the keyboard.

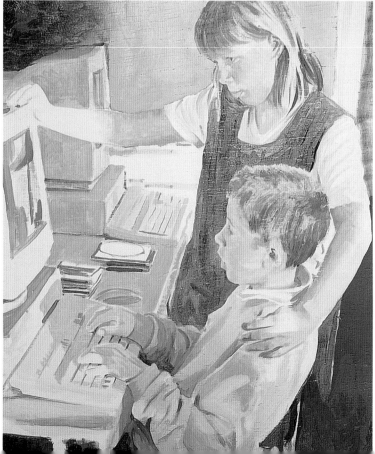

6 When they returned, I continued to work on the heads, hands and feet, slowly increasing the modelling. This was particularly subtle in the case of Liam, as his forehead caught bands of direct light. I also indicated the folds in Angela's tunic. At the time I wanted to emphasize those shadows in order to make her brother's head stand out more. Naples yellow was added to the front of his jersey, and because the balance of the picture was beginning to slip, I balanced everything by adding stronger color to the computer screen. Each tonal change in the head was also echoed in the hand of the model.

At this point I decided that the painting was going nowhere. I was painting it for all the wrong reasons (coercion!), and more importantly I was not enjoying it. I therefore took a cloth soaked in turpentine and rubbed it all off!

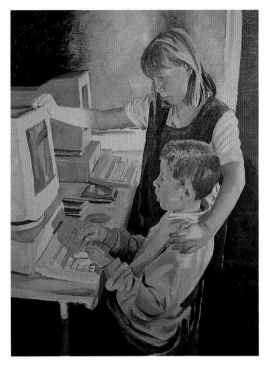

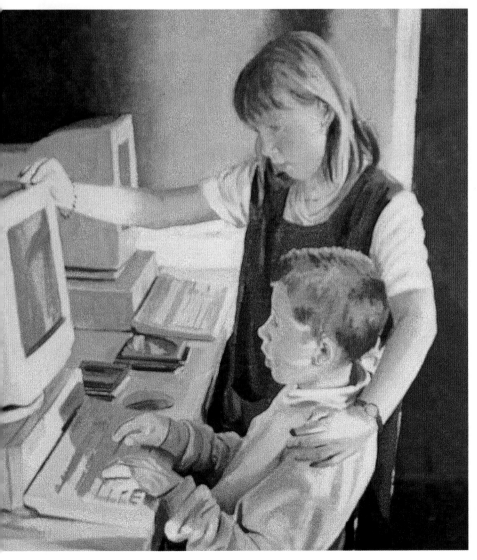

7 On the restart, I followed most of the stages above, obviously taking the shortcuts that had been indicated by the previous experience. It took about ten minutes to get back to something approaching the position I had tentatively crawled to before. You will see that the handling of the paint is considerably more free, and that passages such as those in Liam's arm are more confidently handled. Even the dark under the table that had been giving me cause for concern now seemed happier. I also found it a lot easier to work on a colored ground, which in particular made the placing of the hands, in simple pale Naples yellow strokes, much more free and easy. Having regained lost ground, I quickly added yellow ochre and titanium white along with a few strokes of Naples yellow to Angela's hair, and found a pleasing, mucky yellow-gray lurking on the palette, which worked well for the highlights in Liam's. I also discovered that his short-cropped hair was easy to paint by jabbing at the surface with the 12mm (½in) decorator's brush.

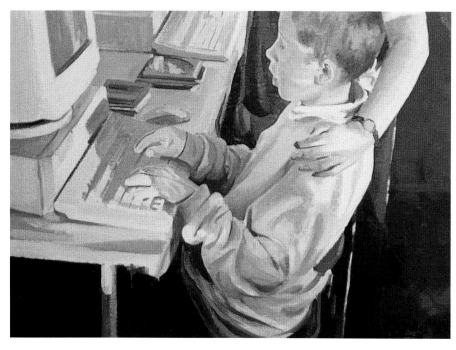

8 It may take you quite a long time to work out the difference between this stage and the last. The area under the table had been causing problems right from the start and everything I tried seemed to produce nothing more than a dead passage of painting. I tried several solutions and eventually indicated Liam's leg with several swiftly applied slashes of paint. The only difference between them and the background is the thickness of paint and the direction of the strokes. Suddenly this part of the painting ceased to be boring and seemed to work quite well.

9 By this point, the picture was becoming quite difficult to work on because it was uniformly wet. However, before putting it aside, I worked on the shadow side of the tunic and Angela's hair. This had taken over as an area of some concern. I tried several different combinations of yellows and white before reverting to my first choice of yellow ochre, Naples yellow, sepia and titanium white. Finally, as I knew the painting would be put to one side for a day or two, I made fairly thick white marks on Angela's hand, which I intended to glaze over when dry.

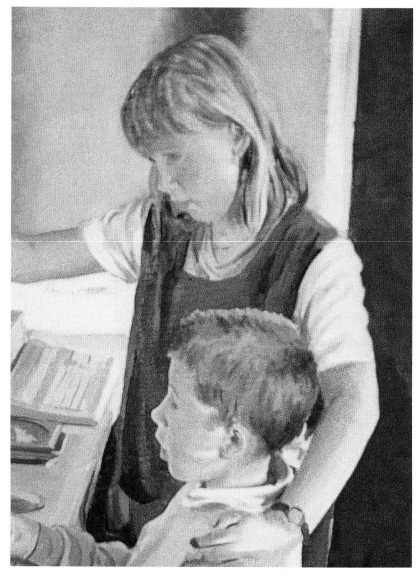

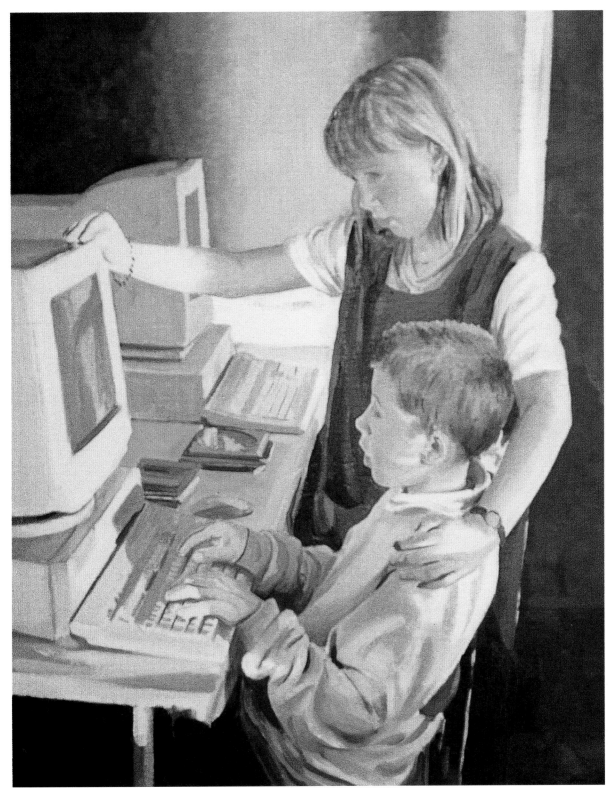

Angela and Liam

After leaving the painting for a few days, I continued and added a thin Naples yellow glaze on the arm draped over the computer terminal and on the hand on Liam's shoulder, also all the highlights were reapplied in a slightly lighter tone. Now that the sketch was complete, I showed it to Angela, who took it around the studio showing it to various friends, so I suspect she is not too distressed by it, although she did not show it to Liam!

5 Pilgrim at Varanasi

Varanasi, known to devout Hindus as Kashi, the City of Light, stretches along a crescent of the river Ganges which itself means, 'born in heaven and descended to earth.' At daybreak it is one of the world's 'thin' places, where spiritual and temporal life splice together. Walking along the ghats some years ago I fell into conversation with a pilgrim; our conversation covered many topics until he excused himself to go and make his morning ablutions in the river. He asked me to wait, and when I produced my sketchbook, indicated that I should paint the river, indeed him in the river, saying 'Maybe this is the way you talk to your God?'

The raised hands are strangely powerful. Try it; who do you become?

This is not a picture in itself but an oil sketch for something bigger and more complicated, indeed, it is the most potentially complex painting in this section of the book. Painting should be seen as a branch of philosophy; it is a visual way of thinking and this picture will eventually be about the power of raised hands, whether in prayer, adulation, surrender or all of those things. It is a difficult picture to write about – but then, if I could use words properly, I would be a writer and not a painter.

1 The panel was covered in titanium white, which was then stirred about to give some indication of the light catching the water. Peculiarly, the river is not the cleanest in the world, but when the light catches, it dances and sparkles with unadorned clarity. I had hoped to show both aspects in my treatment of the shadow cast by my friend. I did not want to try and paint the dark flesh colors on top of the white and so took a cloth and rubbed away the white where the figure was going to be painted. However, I did not take any great care to leave the spaces between the fingers.

2 Payne's gray and titanium white were then used to add some shadow to the water, though of course when you squint into strong light reflecting off water then you do not really see any shadow at all. I also used a very tiny bit of viridian mixed with the white to give a subtle sheen to parts of the painting.

3 All the parts of the pilgrim that were lit by direct light were now painted in, using yellow ochre, Naples yellow, cadmium yellow and cadmium red. I intended to leave these areas very thinly painted so that maximum light could reflect back through the color layers, thus hopefully giving the effect of light catching wet skin. The drawing had to be very accurate because obviously it would not be possible to correct any mistakes – to do this would destroy the optical qualities with which the painting was experimenting. The hands were indicated with very fine glazed orange lines.

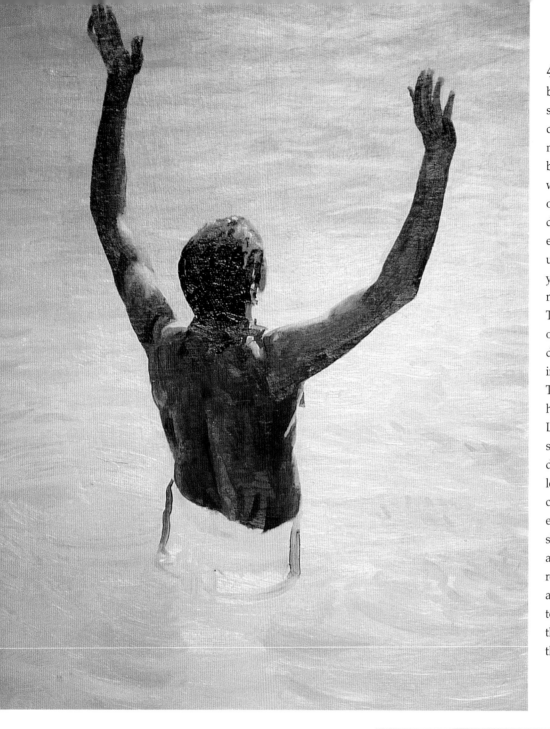

4 The rest of the body is now blocked in with burnt sienna, sepia, Naples yellow and cadmium red in various mixtures. If this was going to be more than a sketch I would have underpainted all of this in blue, probably a deep cobalt blue. It is worth experimenting with underpainting; you will find your own solutions to getting muscle and skin to look right. The muscles of the arms are obviously still three-dimensional, and it is important that they look so. There is a great temptation here (as in the portrait of Louisa) to aim for a silhouette. The hands are very dark against the water, but, looking closely, a thin veil of color seems to drift round the edges. This is partly the light shining through the thin skin and the extraordinary pulsing reflected light from the river. I also indicated where the towel he is wearing meets the water, and scribbled in the hair.

5 The shadow in the water is a very strange color. I painted the towel first with a few strong strokes. I could not get it to look right, and this is the third or fourth attempt, which is still far from perfect. The paint from the previous attempts was removed from the panel with a cloth, then Naples yellow, yellow ochre, cobalt blue and white were mixed with an unidentified gray sludge from the palette's reserve and the shadow was blocked in. I tried this a couple of times; the color seemed fine but the brushstrokes seemed boring.

6 You will notice that the towel has changed yet again, and that therefore the shadow in the water has had to be changed. This time viridian, Payne's gray and cobalt blue were used. (Beware of viridian: it is a strong color that has the habit of permeating through an entire palette.) While this dark paint was on the brush I also worked on the shadows in the hair, and applied a couple of strokes to the right wrist. At one point I thought that that could be the completed picture, but then decided that I was far from happy with the water and added more white highlights to it.

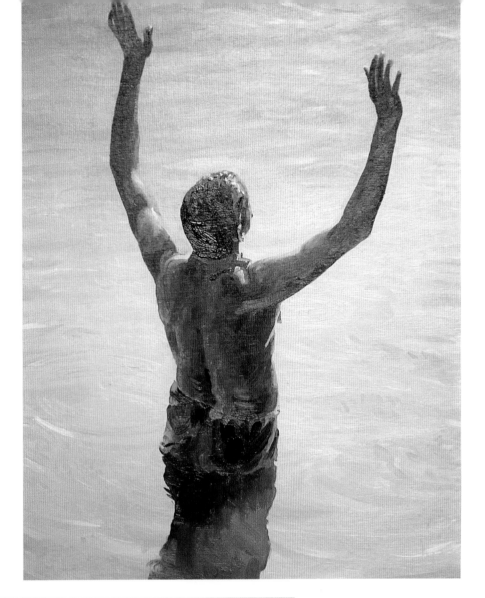

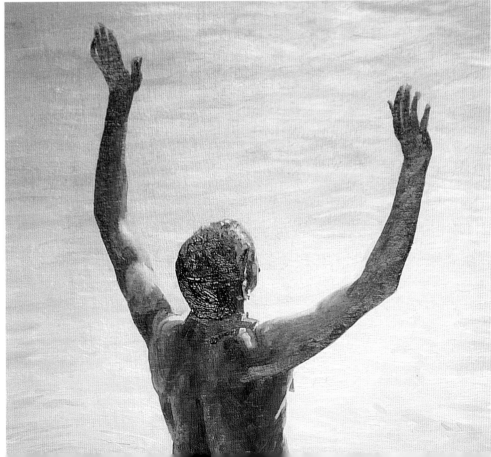

7 I added much more white to the water and then, in an attempt to make it look even brighter, darkened the arms. This was far from successful, so I retreated from that position, leaving only the right arm to redraw slightly.

8 Redrawing the right arm made the back look wrong, so I comprehensively reworked it. (This is a difficult phrase to explain. Imagine a composer taking a tune and shifting it from violins to violas; it is the same tune, but it sounds different. If he then changes it to the clarinets it remains the same tune but now sounds profoundly different.) In this passage I used the same paint as in stage 4, the same brushes and very similar brushstrokes to make it look more solid. I did the same with the upper arm muscles in the left hand. Again, I used the same colors, and varied the mixtures used for almost every stroke of the brush.

9 The painting is nearly complete, but at this point I have to leave it for a few days to see how the paint dries.

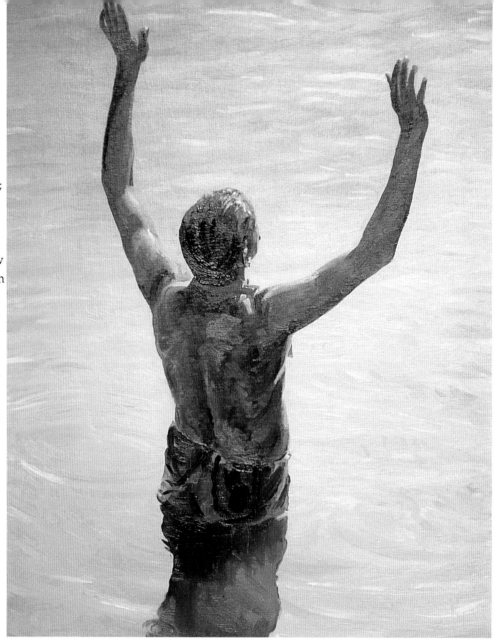

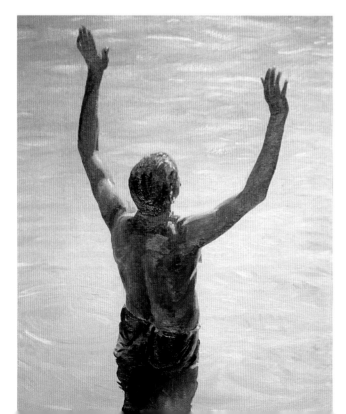

Pilgrim at Varanasi

The final picture is not too different from the last stage. The paint on the left shoulder dried looking rather dead, so I repainted it, and once again more white was added to the water, this in thin skeins of wet paint and thick(ish) traces of dry paint. I am not so sure the final picture tells me any more than the original sketch does, other than that I now know more about how I would handle the subject in oil paint. I suspect that if I do use the image for something serious then it will be in tempera, or in oil with a tempera underpainting – I will have to make another sketch like this if I decide to go down that path.

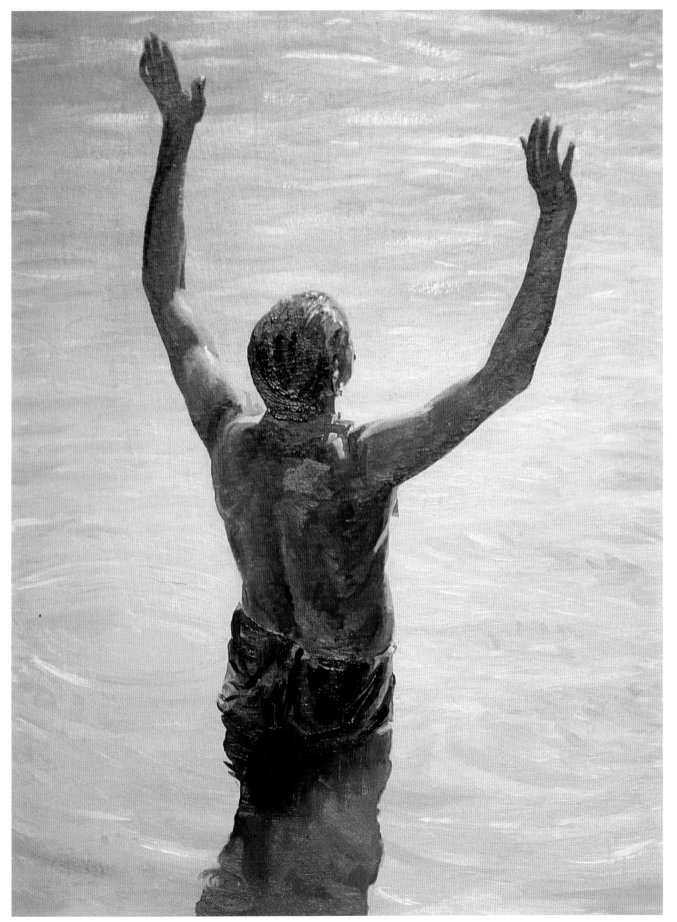

6 Father, child and emu

This painting stemmed from a visit my brother and his daughter made to my studio. They sat playing without realizing that I was drawing them, and late that evening, after everybody had gone to bed, I tried to turn the sketch into something. The initial drawing was done on the back of an envelope; in it I wished to catch their warm intimacy and the complex lighting, and from the point of view of this book it also gave me the chance to have a small child's hands in the same picture as those of an adult. However, to try to make a serious work about something like that would be a bit pointless, so I was pleased that the painting stemmed from the quiet enjoyment of each other's company and not from an academic need. It was late evening and the natural light (from a window both behind and in front of the sitters) was a fading gray. Inside a warm side-light illuminated them.

The painting was made with acrylic paint (a medium that I do not like and rarely use, although I did enjoy making both this and the painting on page 114). It has been painted on paper using a variety of very old watercolor brushes.

1 I started by mixing cadmium red and cobalt blue and sketching in the basic composition. One of the advantages of working from a sketch is that you feel less constrained to follow what is actually there, and I moved the angle of the seat in order to lead the eye into the picture, and gave the curtain a more interesting sweeping curve than the straight hanging example I had originally recorded. I then used a watered-down black to indicate some of the possible areas of shadow, and mixed the red with cadmium yellow to splash in the orange wall in the background.

2 When painting in oils and tempera I employ a lot of underpainting to build up a complex and rich surface. It occurred to me that this should be possible with the quick-drying acrylic paint as well. I therefore used neat cobalt blue to underpaint part of the shadow areas and to indicate the back of the father's head. A splurgy mix of rapidly drying paint was used to explain the seat, curtain and loudspeaker unit. This was more a case of economics than aesthetics – the paint was drying, so better to use it than to waste it!

3 At this point I experimented with several ways of indicating the form of the heads. Once again, underpainting in green would have been an option, and I played around on a scrap of paper trying to find a way to make this work. But nothing I tried seemed satisfactory, and instead I decided to leave as much of them unpainted as I could manage in the hope that this would give the effect of a strong side-light. I had no Naples yellow at hand, so painted in the shadows on both heads with a mixture of yellow ochre, cadmium red and white. I also quickly sketched in some of the studio detritus that lives on the windowsill. Either the emu glove puppet or the father's hand would occasionally creep up and tickle the child on the nose. This gave great amusement to all three. I did think of painting the emu in full 'flight' (that in itself being something of a rarity!) but decided that the atmosphere I wished to convey was best achieved by having the hands and feet as still as possible.

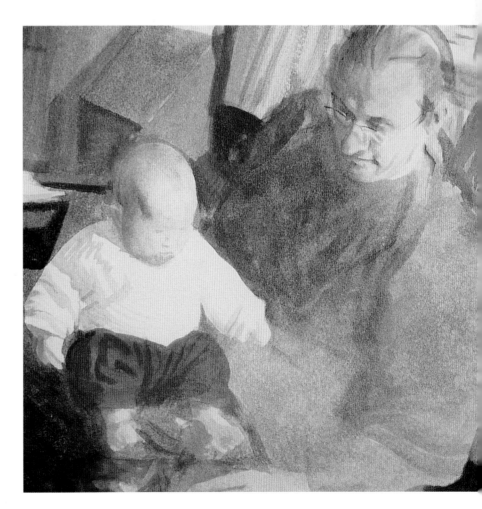

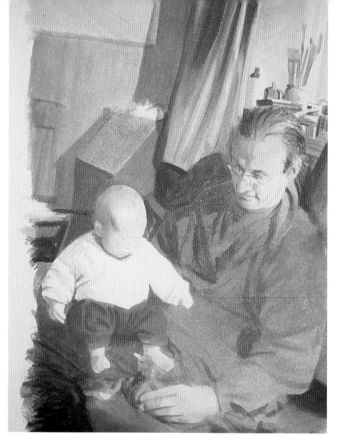

4 I squeezed out more cadmium red than I needed, so before it hardened I painted in the shadows on my brother's jacket. There was a break from strict realism here, as these shadows were actually quite deep in color. I kept them light, hoping to raise the tonal structure of the painting, which at this point I thought might be kept quite even. I also worked on the curtain in the background.

5 Most of the changes in this stage can be seen on the window ledge where a small still life was forming, and which for a while seemed in danger of becoming the dominant subject. It was obvious now that the blue line which indicated the back of the father's head had (or was becoming) integrated into the scheme of things. Using the same paint I used for the objects by the window, I then painted in the dark shadows to the left of the baby.

6 The still life section of the picture is now complete and does not detract too much from the rest of the painting. The father's hair is also now painted in properly; you will have noticed that it has slowly become more delineated. I have also added quite dark shadows at the back of the curtain and behind the father's arm, and there has been some tightening up of the facial features of both figures. It was at about this point that I abandoned the notion of keeping a fairly equal tonal structure across the painting, and added more depth to all the shadows except those on the red jacket. Finally, I blocked in the telephone on the loudspeaker unit.

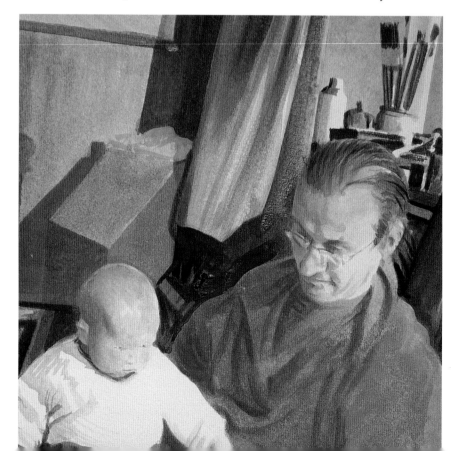

7 The red jacket was beginning to cause some concern. I did not want to deepen the shadow area, but the entire passage looked flat. I scumbled some white around the right-hand shoulder and down the arm with the intention of glazing red over the top. I also consolidated the hand that was holding the toy emu by drawing in white paint and by scumbling dry cadmium red mixed with white across the lines.

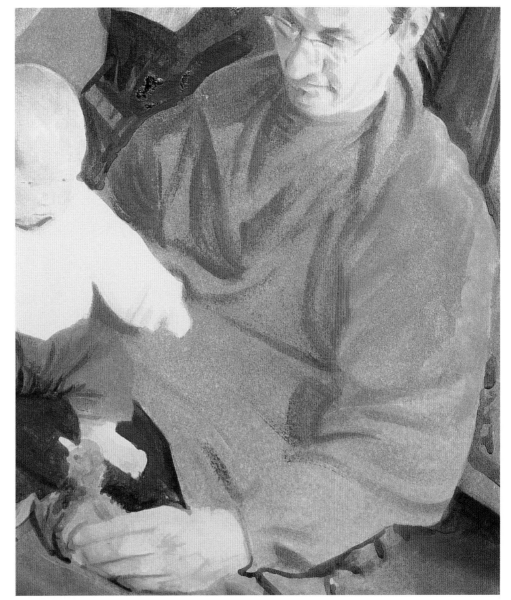

8 I was quite close to abandoning the painting at this point, and after painting in a series of vertical strokes on the orange wall, I put it down to make a cup of coffee. I placed the painting upside down on the easel and sat back to see if I could determine what the problem was. Placing your work upside down helps you to see it as a series of abstract shapes and, very often, glaring color faults or compositional errors become very obvious. Another trick is to look at it in a mirror. I could see nothing too terrible, however, and decided that I would try to take it a bit further. Eventually I used a fine brush and a warm mix of paint from the rapidly drying palette to further delineate my brother's hand. This was becoming a problem as the emu and hand were beginning to become the central point of the painting. I therefore took a piece of sandpaper and rubbed them back, before adding a thin wash of Naples yellow and cadmium red.

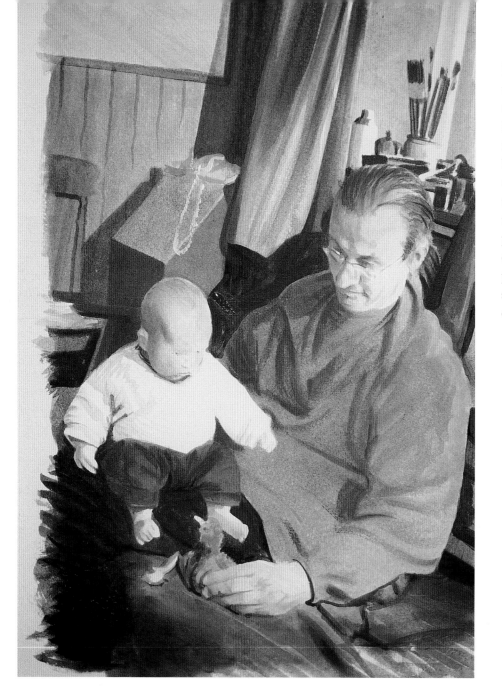

9 Using yellow ochre and white, and cadmium red and white, I worked on the heads and hands of both models. Very little work had been done on the baby's hands and feet, but I decided I liked the simplicity and kept them that way. For all intents and purposes, the painting was now complete, however, I always prefer to keep a picture in the studio for some time to be certain it is 'finished.'

10 The telephone cord is the obvious addition to the composition here. Less obvious is the repainting of nearly all the areas in shadow, this time with considerably stronger and more flowing brushstrokes.

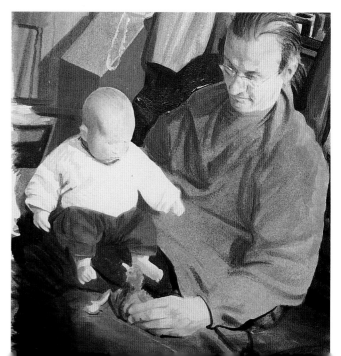

Father, child and emu

Several days later I added more paint to the chair that the models are sitting on, and some white to the toy emu's leg. I also added very subtle washes of white to both heads and all the hands. More important is the work I did on the right-hand side of the red jacket and in the deep pink lines added to the shadow area. This picture has not converted me to acrylic paint, but at the end of the day I am not too unhappy with the result. The emu is delighted!

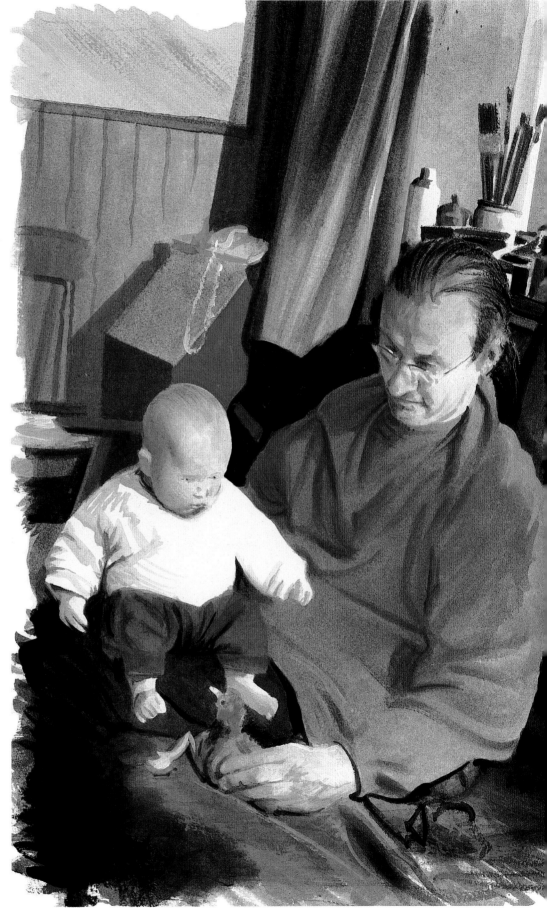

7 Rickshaw driver, Dacca

While I was sketching this gentleman I attracted a considerable crowd, which eventually brought me to the attention of a passing policeman. He elbowed his way to the front of the crowd and asked me what I thought I was doing. 'Painting,' I replied.

'Why do you come here?'

'Because I like it.'

'What is it you like? You do not like this?' He challenged, indicating the rapidly thinning crowd.

'I like it very much,' I replied.

'You a tourist?'

'Yes,' I said, 'I suppose you could call me a tourist.'

'You can't be.' He stated firmly, 'Here we do not get tourist.'

With this he left me and my model. The rickshaw driver grinned at me and shrugged his shoulders. The crowd rematerialized from nowhere and with a great sense of solidarity we completed the sketch.

This painting is in acrylic (on paper) and attempts to keep something of the freedom of the original sketch. I decided from the outset that, ideally, I was going to keep the background white even though this meant leaving out a glorious highlight running along the top of the rickshaw. A rickshaw driver has a very hard life, and his work builds enormous leg muscles and very powerful feet. I was not too concerned about emphasizing this in my painting, but was aware that it was not unimportant.

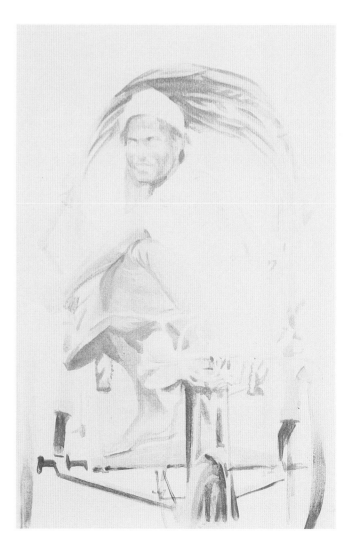

1 I quickly established the basic composition and rapidly blocked in his head and arms. This was done with burnt sienna, sepia, cadmium red and cobalt blue.

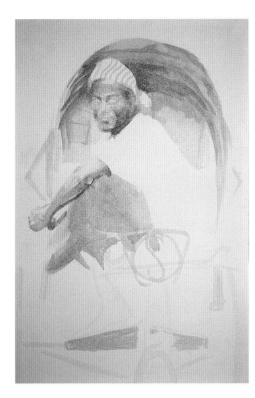

2 My intention to begin with was to try and keep the painting of the rickshaw as free as possible. The Dacca rickshaws are rightly famous for their wonderful decoration (indeed, I first became aware of them through an exhibition in London at the British Museum) and the portrait rapidly became a sincere means of recognizing the stunning talent of a fellow artist. It seemed only correct, therefore, to give his vehicle the same attention as the driver/artist himself. With this now in mind, a lot of serious thinking had to be done in the placing of the machine's various component parts.

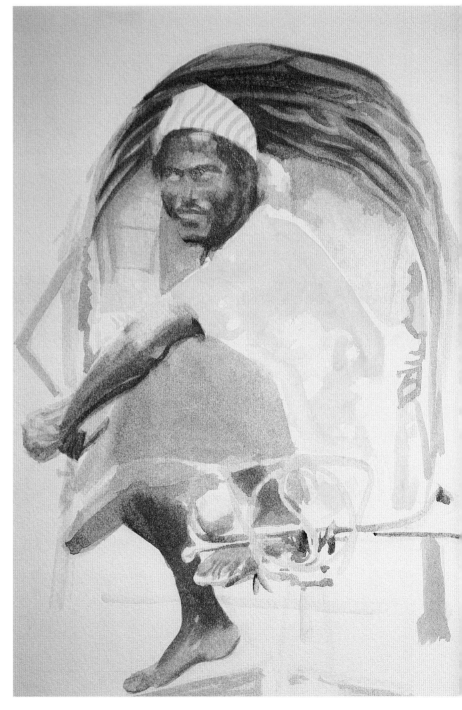

3 The driver's shirt was heavily patterned and very bright. Instead of trying to paint the pattern onto the shirt, I thought I would paint the entire thing in its lightest color and then paint over that. This would maintain the maximum reflective power of the white paper, thus giving very bright colors. The canvas back of the rickshaw was rolled up, and I drew this in with a mucky brown mixture that I found on the corner of the palette.

PROGRESSING TO PAINTING

4 A considerable amount of detail was added to the rickshaw itself, and the basic pattern on the shirt was sketched in. When you are drawing with an (ever-growing) audience you do not fulfill your part of the entertainment unless you attempt to produce a likeness of your sitter. In the original sketch my attempts produced a lot of good-humored banter, advice and downright hilarity! In the studio one does not have to be quite so fussy, and it was with that ease that I painted in the basic features of the driver. This was done using cadmium red, yellow ochre and burnt sienna. I also began to add some detail to the arms, leg and foot. It is important when painting to constantly remind yourself that there are no outlines in nature and that even if a foot appears to be a silhouette it is, in fact, a three-dimensional object. You must make sure your paint marks indicate this.

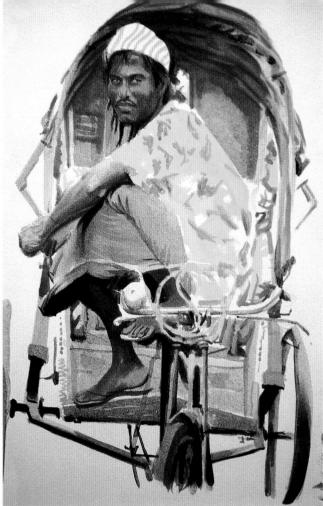

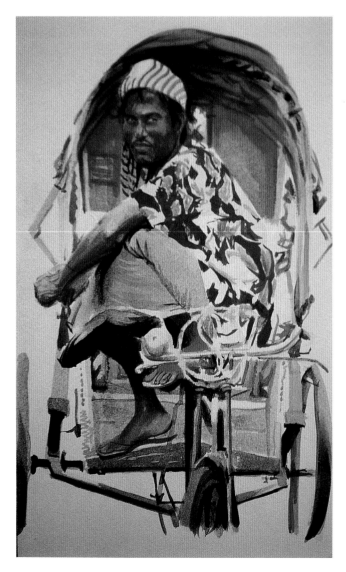

5 Further detail was added to the shirt, and then I sat back with a cup of coffee and studied the picture for 20 minutes or so. This side of painting is often neglected. It is perfectly possible to enter the studio at 8:30 in the morning and sit down in front of a painting – the day's work could easily be sitting, looking, thinking and planning before making a slight but vital adjustment just prior to shutting up shop in the evening. The student to whom I referred in the introduction to this section will often come into the studio in the morning and quickly make a couple of adjustments to her picture. Then she will go off into a corner and make all sorts of things – drawings, sketches and small models – but will occasionally throw a sly glance at her picture, as if trying to take it by surprise. Towards the end of the day she will, more often than not, pick up a brush and confidently make bold improvements. She has not been taught to do it, but has developed this very professional way of working for herself. Once again, if an ten-year-old can do it, so can you. My coffee break led to a number of cooler colors being added throughout the painting surface.

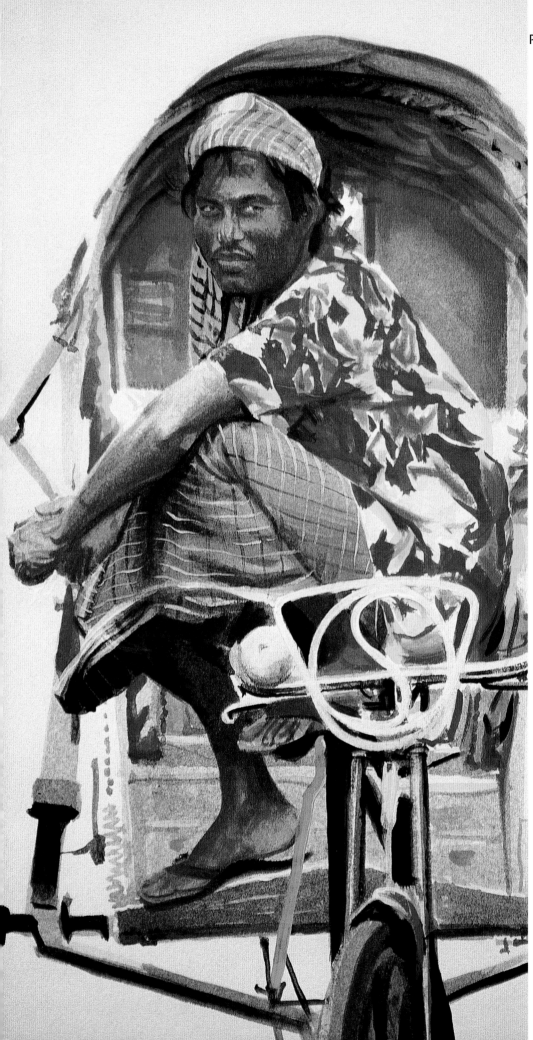

6 I now added detail to the turban and to the cloth around his waist. In doing this, I tried to indicate the form with every brushstroke. I also worked on the muscles in the arm, drawing them in with thin washes of orange. On the front of the bicycle handlebars was a large round shape containing the letter S. This was a strange green color, but to keep this meant losing it in the mass of the rickshaw. I therefore painted it white with the full intention of glazing it in some transparent color yet to be decided. In fact, if you skip to the final work you will see that I decided to leave it white.

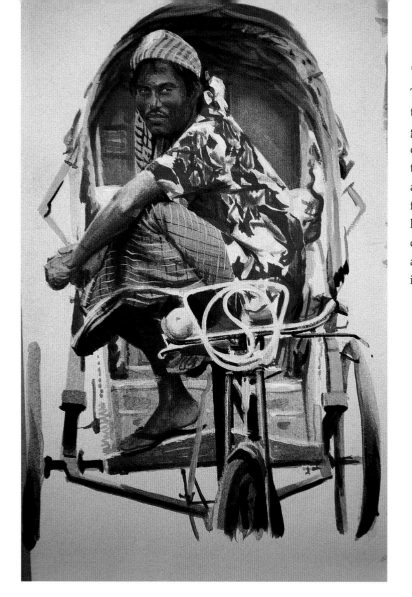

7 The changes at this point become very subtle. The back of the rickshaw was scumbled over using the identical color in which it was already painted, giving the paint a quality like the texture of the canvas. I painted dark blues, reds and purples into the darker shadows so they could be overpainted, and a minor amount of manipulation on the forehead and foot. (In fact, I repainted all of the head and foot, then removed the reworkings completely with a damp cloth, reworked both again – and once again decided that there was no improvement, and finally left it as it was originally!)

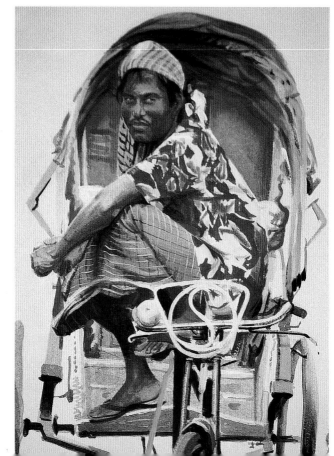

8 The painting is, I think, just about complete. I added dark blue to the handle of the bicycle and overpainted all the shadow areas with the same color. This, I hoped, would give a variety of warm and cool colors throughout the painting.

Rickshaw driver, Dacca

The final work differs little from the previous stage. There is some tightening up in the portrait of the driver and a purple splodge added to his hair and turban. Although I have shown several stages of working for the purpose of the demonstration, the complete work was actually painted in only two sittings, with a break for coffee in the middle.

8 Tibetan trader counting money

In the north of Nepal, high in the Himalayas and close to the Tibetan border, there are several villages that have weekly markets. Traders, who cross high mountain passes out of Chinese-controlled Tibet to deal in a wide variety of goods, use several of these. They are hard and proud people whose recent history has been almost totally ignored by Western governments. The gentleman in this portrait was dealing in meat and clothes and kept his money hidden in a pocket in an inner garment; he is seen here lifting several layers to give a woman some change. He wore a pair of Western-style denim jeans under which could be seen a pair of trousers made out of a sheepskin. My Nepali is not wonderful and my Tibetan even worse, but we understood each other well enough for him to trade a leg of mutton for a small portrait of himself.

The Tibetan people have no tradition of washing and therefore their hands have an extraordinary patina which must at one time have been very common, but is now experienced rarely. This color is very difficult to convey, indeed the difference is more textural than chromatic.

1 As always when working in watercolor I drew in the main shapes using nothing but clean water on my brush. I then threw down the basic drawing of the head and the position of the hands.

2 Almost immediately I realized it was wrong and so plunged the complete painting into the bath where, using a large decorator's brush, I removed as much of the paint as I could. The paper was then dried with a hairdryer, and I started again. You will notice that I could not remove all of the previous false start and have just painted over it.

3 The second attempt was immediately better than the first, and without pausing I quickly sketched in as much of the detail in the head as I could without the paper becoming too wet. All of this was done with burnt sienna, cadmium red and yellow ochre. The trader's hat was made out of a skin, and I started to paint it by making some marks which helped dry off the brush while working on the head.

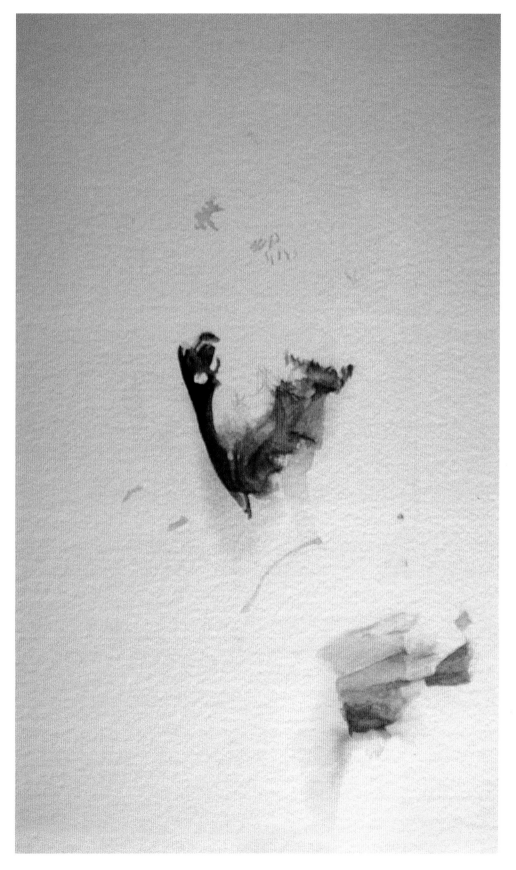

4 Eventually the head became too wet to work on, so while it was drying I painted in the long scarf which he had draped round his shoulders. This was painted in a thin wash of alizarin crimson. I also drew in my first thoughts regarding the folds in his jersey.

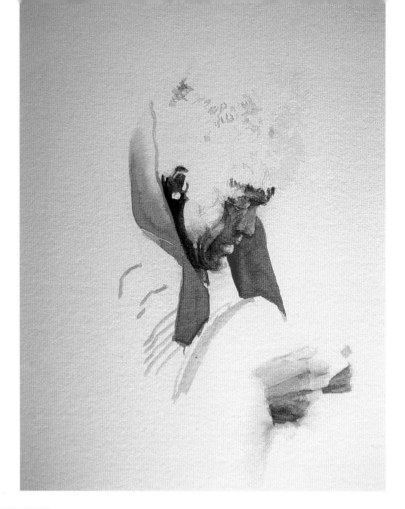

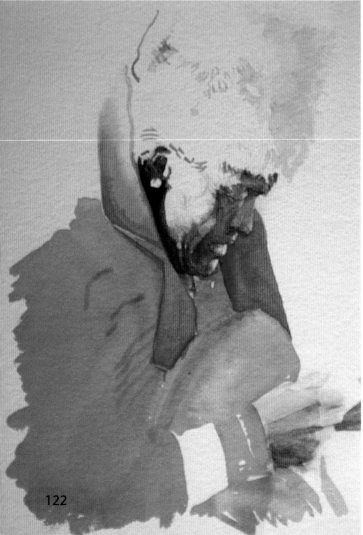

5 I used a thin wash of cobalt blue and Payne's gray to paint the shape of the jersey and shirt. I was aware of the fact that if this were painted wrong it could be covered up easily by the next wash. I also used some of this wash to darken parts of the eye, chin, neck and hands, and to indicate the extent of the shadow on the hat.

6 Once the jersey area had dried, wash number two was applied. This was also Payne's gray and cobalt blue, but in a slightly stronger mix than before. I left the light patterned area alone and, working very quickly, tried to indicate where the folds caused by his bent arm would be. I also swamped the hands with a very delicate wash of yellow ochre, so delicate indeed that it does not show on the photograph of this stage.

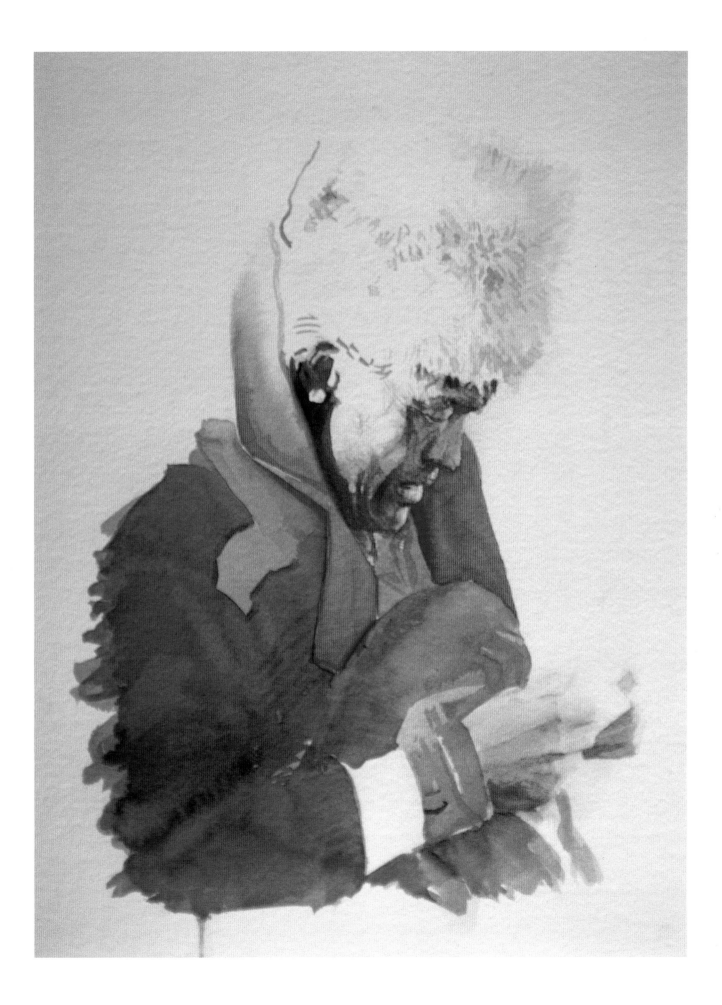

7 I dried the painting with a hairdryer and repainted the jersey with a further mix of Payne's gray and cobalt blue, with the mix this time being more gray than blue. Once again I attempted to draw in the folds in the cloth, this time more successfully. The shape of the uplifted jersey (actually, jerseys) is very strange, and I spent a few moments making it look convincing. I then went back and added a few marks to the head, each generally tightening it up. The wash applied to the hands was now nearly dry, and before it set completely I dropped a further slightly stronger wash of yellow ochre on top. This was in an attempt to catch the quality of hard-working hands.

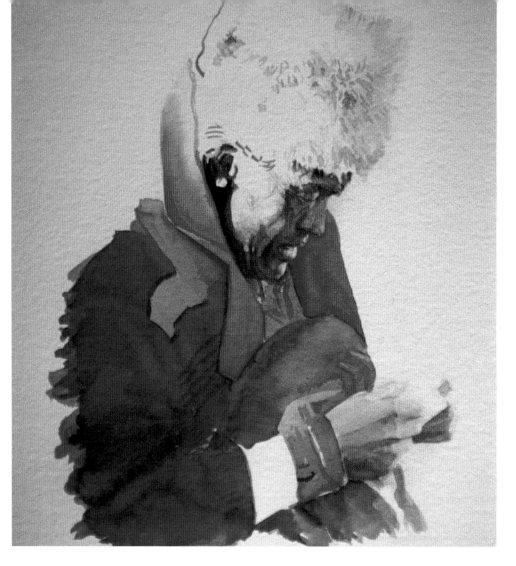

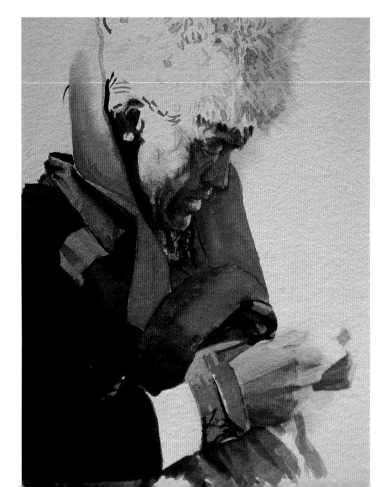

8 I darkened the shadows between the scarf and the jersey and under the chin, and once again added a mark or two to the head, mostly around the eyes. By now, in well under an hour (most of which had been spent photographing it) the painting was nearly complete. A final wash or two of yellow ochre, sepia and burnt umber were added to the hands.

Tibetan trader counting money

I added a few details to the completed painting: the turquoise earring, the 100-rupee notes and a general tightening up of the hands with much drier paint. Finally, I turned my attention to the hat, and with a mixture of Naples yellow and Payne's gray, added a few marks to make it look as furry as I could.

Acknowledgements

In the preparation of this book I have been much helped by conversations with many colleagues: Mary Rosengren, Laura Kingswood, Wendy Sutherland, Peter Haining, Chris Robinson and Marshall Anderson taking the brunt of this.

Jennifer Cattanach, Mairi Finlayson, Kate Taylor, Donalda Nicholson, Norma Maclellan, Mary Kelly, Margaret Stewart and Doreen Young have been constantly supportive in my efforts to find new ways to teach fine art.

The book would not exist without the patience of all who modelled for me, in particular Gary Cameron, Catriona Jackson, Jackie Robertson, Louisa Laing, Angela and Liam Macdonald, Fiona Marwick, Janet Gardiner, Malcolm Macsween, Parbati Pariyar, Kirsty Grace, Brian St John, Josie Keast and Roddy Fairley.

Thanks also must go to Sally and Christian Welburn who helped to 'check' the manuscript, and to everybody at David and Charles who have been extraordinarily patient.

Finally, my warmest thanks must go to all the students of Room 13 who have, over the years, constantly responded with good humour and enthusiasm to some very unusual teaching concepts. In particular Jodie Fraser, Alan Wilson, Donette Coutts and Leanne Stafford who have all, in their own way, taught me much.

Image on page 19 courtesy of the David Hockney Studio (© David Hockney)
Page 12 Photo: AKG London

Index